RMS
QUEEN MARY

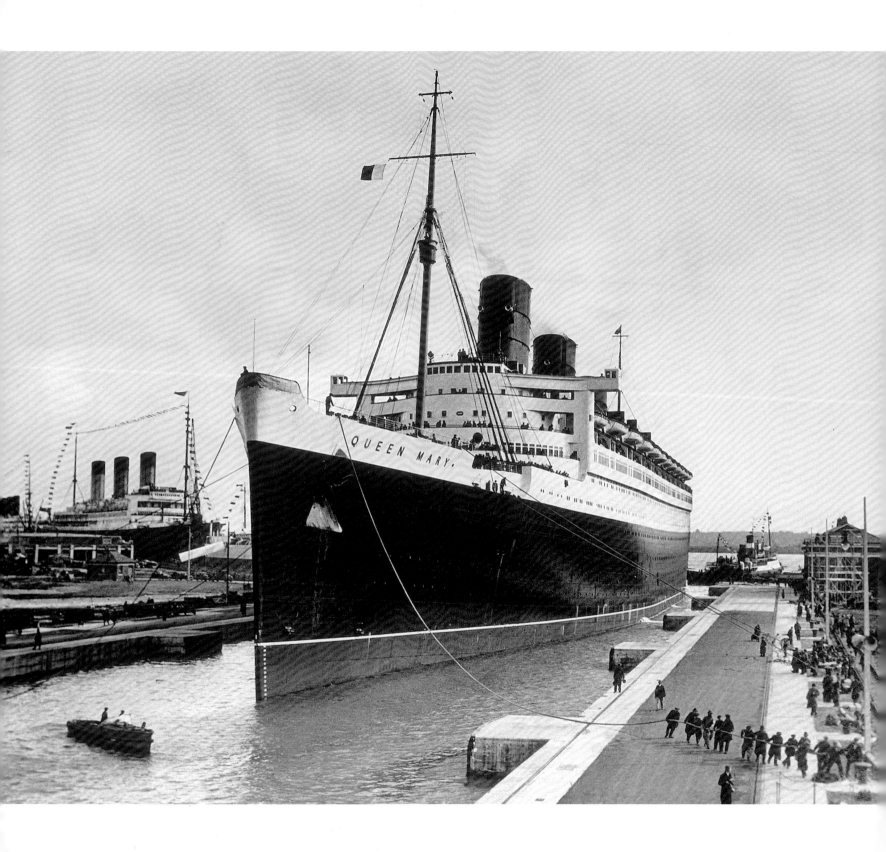

RMS QUEEN MARY

ANDREW BRITTON

Frontispiece:
The RMS *Queen Mary* is seen cautiously entering the King George
V Graving Dock in 1937 for annual overhaul. (Britton Collection)

First published 2012
Reprinted 2015

The History Press
The Mill, Brimscombe Port
Stroud, Gloucestershire, GL5 2QG
www.thehistorypress.co.uk

British Library Cataloguing in Publication Data.
A catalogue record for this book is available from the British Library.

ISBN 978 0 7524 7952 1

Typesetting and origination by The History Press
Printed in Malta by Melita Press.

CONTENTS

INTRODUCTION

I am told that I was just ten days old when I was introduced to the Cunard RMS *Queen Mary* at the Ocean Dock in Southampton. Although I was born in Warwick, my father's family and friends originated from Southampton and soon after leaving hospital I headed south to meet them, one member of the party weighing in at 81,237 tons! My grandfather was leader of the orchestra on the *Queen Mary* and my Uncle Norman was also a pianist in the same orchestra. Other family members and friends worked on the Cunard White Star Line ships and the *Queen Mary* and *Queen Elizabeth* became a major part of my life when my family frequently visited my father's home city. Meeting the Cunard Queens, waving them off on their transatlantic voyages, and listening to the unforgettable deep tones of their whistles is in my blood.

It therefore came as a great shock to me when in 1967 my beloved *Queen Mary* sailed away on her final voyage to Long Beach in California. I can only describe this sad occasion as like losing a very close family member whom I dearly loved. As she gently passed away down Southampton Water, I looked in silent disbelief with my family from the vantage point at Western Shore, Southampton. I can vividly recall my father with a tear in his eye and his voice, overcome with emotion, questioning, 'How can they let her go?' All around, thousands of mournful spectators gathered together reminiscing about memorable bygone days on this national icon as so many of them had worked aboard or had close connections with her.

Now many decades on in the twenty-first century, I try to relate to my own sons, Jonathan, Mark and Matthew, what it was like to experience the world's favourite liner, to see, hear, smell and touch the RMS *Queen Mary*. They listen in almost disbelief to favourite family *Queen Mary* tales of film star passengers, travelling royalty and our wartime leader Winston Churchill. This great liner was totally unique and had her own distinctive character with Art Deco, the warmth of the crew and sheer opulent luxury aboard. Of all the great ocean liners I have seen and been aboard, there has been nothing like her since she entered service in 1936. 'The Mary' is not only a legend in the annals of my family history, she is also regarded as the world's favourite liner. How I wish she could have stayed at home in retirement at Southampton for future generations to enjoy.

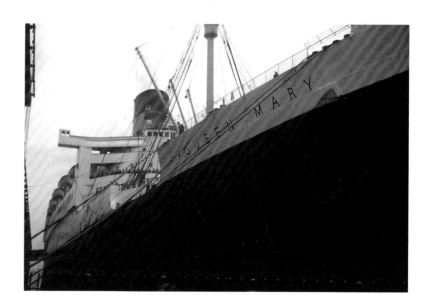

This is the view that awaited passengers on the Cunard RMS *Queen Mary*, who began all her voyages at the famous Pier 92 at New York Harbour. The letters of the name *Queen Mary* on the bows were 2½ft high and nearly 55ft in length. (Britton Collection)

ACKNOWLEDGEMENTS

The idea for a colour ocean liner book series began with my cousin Jennifer. News soon spread around the family to Uncle Joe Webb (ex-RMS *Queen Elizabeth* fame) and Auntie Jean in Southampton who began to encourage and arm-twist. Uncle Joe's brother, Bernard Webb (ex-RMS *Queen Mary*), added his support and the project was on.

A huge project like this could not have come about without the help of my brother-in-law Mike Pringle who meticulously scanned each and every slide (several thousand of them) for this series. This amounts to months of unseen hard work. Without his help, this book and the whole series would not have come into being. I also owe my sister Ruth a massive thank you for all her patience and encouragement. A special thank you must go to my son Matthew for work on cover designs along the way and my wife Annette for putting up with masses of colour slides, boxes of ocean liner logbooks and shipping artefacts.

Many friends have helped by allowing me to include their original work and several have generously donated their material. I am indebted to Mrs Hilda Short and the Estate of the late Pursey Short for the donation of Pursey's colour slide material of Southampton Docks. Pursey's aerial photography of the docks is second to none. Thanks also to the Estate of the late Gwyilym Davies for their support in acquiring the entire collection of maritime slides of this distinguished photographer. I am very grateful to Randy Holmes and the Church of Latter Day Saints, USA, for allowing me to purchase the entire Arthur Oakman original slide collection for inclusion in this and future books. Additionally, the G.R. Keat and Norman Roberts slide collections have been sold to me for specific inclusion in this and future books for which I am extremely grateful. Petroleum giants Esso and the Cunard Line have very generously given me their original slides of Southampton Docks and the liners. Some of this material will be included in future publications in this series. Similarly, I am sincerely grateful to Graham Cocks for the generous gift of all his slides to this project. Bryan Hicks, John Goss, David Peters, John Cox, Alan A. Jarvis, Tom Hedges, A.E. Bennett, Richard Clammer, Marc Piche, Michael Lindsay, Barry Eagles and John Wiltshire have also given me permission for their fabulous original work to be included and I am very grateful to them. I would also like to thank Fran Muessig who generously provided the Braun Brothers' outstanding original slide collection for use in this book. A special mention must be made of David Boone from the USA, alias the 'Tugboatpainter'. So many of the colour slides included in the Britton Collection have originated from him. This collection also includes the outstanding slides taken by Ernest Arroyo.

Over the years I have enjoyed meeting and interviewing on tape many people who have generously given their time and hospitality. I would like to thank: Jean Webb, Joe Webb, Bernard Webb, Captain Peter Davidson, Commodore Geoffrey Marr and Commodore Donald MacLean. They have always welcomed me into their homes and been available at the end of the telephone to double-check facts. I will forever be in their debt.

My lifelong friend and mentor, the renowned author, railway and maritime photographer R.J. 'Dick' Blenkinsop, placed his entire collection at my disposal. He even included some of his slides in a public lecture he was giving at Stratford-upon-Avon to assist me with making selections. As always Dick has patiently encouraged me with stimulating ideas and positive suggestions for illustrations and content in this and other books in the series. I extend my sincere thanks to Dick.

I must also extend my sincere thanks to Michael Jakeman who checks all my completed written manuscripts.

I dedicate this book in the series to my wife, Annette.

Form L.L. 2
(Special)

LLOYD'S REGISTER OF SHIPPING

UNITED WITH THE BRITISH CORPORATION REGISTER

No. 66526 FOUNDED 1760 RE-CONSTITUTED 1834

International Load Line Certificate

Issued under the authority of the Government of the United Kingdom of Great Britain and Northern Ireland under the provisions of the International Load Line Convention, 1930

Ship's Name	"QUEEN MARY"	Official Number 164282
Port of Registry	Liverpool	
Gross Tonnage	81,237	

Freeboard from deck line. *Load Line.*

Tropical	35	feet	5⅝	inches (T).	0	inches above S.
Summer	35	feet	5⅝	inches (S).		Upper edge of line through centre of disc.
Winter	35	feet	5⅝	inches (W).	0	inches below S.
Winter North Atlantic {	NOT REQUIRED	feet		inches (WNA).		inches below S.

Allowance for fresh water for all freeboards 9⅝ inches.

The upper edge of the deck line from which these freeboards are measured is nil inches above the top of the ⅝" korkoleum on steel upperdeck at side.

When more than twelve passengers are carried, the freeboard of the ship shall be governed by the terms of the Passenger and Safety Certificate.

L ⊖ R F

This is to certify that this ship has been surveyed and the freeboards and load lines shown above have been assigned in accordance with the Convention.

This Certificate remains in force until 11th March, 1968

Issued at London on the 12th day of March, 19 63

pro Secretary. *Deputy Chairman.*

The Annual Survey becomes due on 12th March each year.

NOTE.—Where sea-going steamers navigate a river or inland water, deeper loading is permitted corresponding to the weight of fuel, etc., required for consumption between the point of departure and the open sea.

I have surveyed this ship for the purpose of seeing whether this Certificate should remain in force and the Survey has been completed to my satisfaction.
Signature of Surveyor *John R Wright* Place *Southampton.* Date *10th March 1964.*

I have surveyed this ship for the purpose of seeing whether this Certificate should remain in force and the Survey has been completed to my satisfaction.
Signature of Surveyor *John R Wright* Place *Southampton.* Date *12th February 1965.*

I have surveyed this ship for the purpose of seeing whether this Certificate should remain in force and the Survey has been completed to my satisfaction.
Signature of Surveyor *John R Wright* Place *Southampton.* Date *9th February 1966.*

I have surveyed this ship for the purpose of seeing whether this Certificate should remain in force and the Survey has been completed to my satisfaction.
Signature of Surveyor *J. A. Barton* Place *Southampton.* Date *6th February 1967*

The provisions of the Convention being fully complied with by this ship, this Certificate is renewed till

London 19 . Secretary. Chairman.

I have surveyed this ship for the purpose of seeing whether this Certificate should remain in force and the Survey has been completed to my satisfaction.
Signature of Surveyor Place Date

I have surveyed this ship for the purpose of seeing whether this Certificate should remain in force and the Survey has been completed to my satisfaction.
Signature of Surveyor Place Date

I have surveyed this ship for the purpose of seeing whether this Certificate should remain in force and the Survey has been completed to my satisfaction.
Signature of Surveyor Place Date

NOTES.

1. This Certificate must be kept framed and posted up in some conspicuous part of the ship so long as it remains in force and the ship is in use.
2. The Winter North Atlantic load line applies for voyages across the North Atlantic, North of latitude 36° N., during the winter months as defined in the Load Line Rules.
 The periods during which the other seasonal load lines apply in different parts of the world are as stated in the Load Line Rules.
3. This Certificate will be cancelled by the Minister of Transport if—
 (a) material alterations have taken place in the hull or superstructures of the ship which affect the position of the load lines; or
 (b) the fittings and appliances for the protection of openings, the guard rails, the freeing ports or the means of access to the crew's quarters have not been maintained on the ship in as effective a condition as they were in when the Certificate was issued; or
 (c) the Periodical survey is not made as required by the Load Line Rules.
4. Where this Certificate has expired or been cancelled, it must be delivered up to the assigning Authority and the ship may be detained until such requirement has been complied with, and if any owner or master fails without reasonable cause to comply with such requirement, he shall for each offence be liable to a fine not exceeding ten pounds.

Appliances for closing access openings in bulkheads at ends of detached superstructures	
Forecastle 	Hinged steel doors
Bridge, Fore end 	No openings
Bridge, After end 	Hinged steel doors
~~Raised Quarter Deck~~ 	--
Poop 	--
Temporary appliances for closing openings in superstructure decks	
--	

International load line certificate. This important document resided on board the *Queen Mary*, detailing her insurance requirements. When she retired to Long Beach, Treasure Jones took it off the wall on behalf of Lloyds. Subsequently it went to Captain Marr. (Britton Collection)

ABOUT THE AUTHOR

Andrew Britton is a retired school teacher and a life-long shipping enthusiast with family connections going back to the White Star Line. His grandfather, Alfred Britton, was bandmaster for the White Star Line and was due to sail aboard the ill-fated *Titanic* from Southampton; he was prevented from doing so by his grandmother who had an eerie premonition of disaster. His uncle, Norman Britton, was a popular Cunard White Star pianist and performed on many of the shipping line's ocean liners. Another uncle, Henry 'Joe' Webb, was an engineer on board the Cunard RMS *Queen Elizabeth* and he later worked in the docks. Uncle Joe's brother, Bernard Webb, worked aboard the RMS *Queen Mary* and so it could be said that Southampton shipping was in the blood.

Andrew is also passionate about steam railways and has written six books on the railways of the Isle of Wight. He has contributed to various railway enthusiast magazines and he is also the co-writer of the BBC TV documentary *For the Love of Steam*. He is a part-owner, together with family and friends, of eight British steam locomotives that operate on the Swanage Railway and other heritage railways.

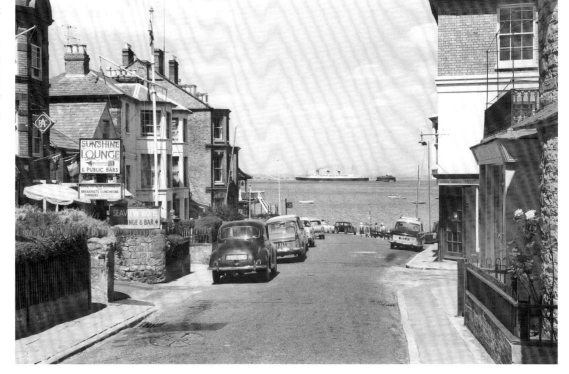

The *Queen Mary* became an everyday sight to generations of tourists visiting the Isle of Wight. This scene in the 1960s, at Seaview, just south of Ryde, shows the transatlantic liner gliding past on the final leg of her voyage from New York–Cherbourg– Southampton. (R.J. Blenkinsop)

LAT. OBD.	LONG. CHRON.	COURSE AND DIST.	VARIATION.	BEARING AND DISTANCE.

P.M. 1230 Trial of main Engines, Steering gear, Whistles telegraphs + all Navigational equipment tested + correct. 1330 Completed loading N° 1. 1345 Completed loading N° 2 + AB Room. Stations. 1400 Completed embarkation. 1413 Singled in 1415 S.B.E. 1420 Tugs fast. 1430 Gangway landed 1432 Let go aft. 1435 Slow Astern. LEFT BERTH. 1436 Let go ford. H + EAR. 1439 Clear of Pier. Swinging 1446 Ship Pointed. proceeded. 1450 Dock Pilot + Tugs away. 1456 Pier 68. 1513 Castle gardens. 1518 Liberty. 1527 Robbing Reef. 1537 Quarantine Search made for stowaways - none found. 1539 Forts. 1549 N° 18 Δ. 1553 N° 14 Δ 1556 N° 10 Δ. Gentle breeze cloudy, fine + clear. 1610 N° 2 A Δ. 1617 Gedney Δ. 1621 Stop Appr. Pilot. 1625 Pilot away Full Ahd. R.O.E. 172 Revs. 1636 (2036 GMT) DEPARTURE. ACLV brg 070°–1' S/c 095. at. 40.27 N. 1645 Long. 73.45 W Passengers mustered at Boat Stations, wearing lifebelts + instructed. Gentle breeze, slight sea, O'cast + clear.

2100 Staff Captain's Rounds. 2300 Stowaway discovered. Seaman ALEC LANGLEY KENNEDY AGE 37 BRITISH SUBJECT. BERMUDAN PASSPORT N° 20161 2358 (O.T.) Nantucket L.V. brg 000°–2.5'.

Light breeze, slight sea, O'cast + clear. Lights hung out at Sunset P.M.

Midnight. clocks advanced 60 mins.

Extract from the log book of the *Queen Mary*, Voyage No.215, by Captain D.W. Sorrell. Here, he reports the discovery of a stowaway.

POTTED HISTORY OF THE CUNARD RMS *QUEEN MARY*

The *Queen Mary* is a floating kingdom who, with her Cunard sister, the *Queen Elizabeth*, could not be sunk by Hitler and undoubtedly shortened the War. This fine vessel is a symbol of the British nation and is the world's favourite liner.

So proclaimed Prime Minister The Right Hon. Sir Winston Spencer Churchill MP at the 8 a.m. press interview in the Verandah Grill shortly after docking at Pier 90, New York, in January 1953.

The world's favourite liner began life in December 1930 at John Brown & Company Shipbuilding and Engineering shipyard on the banks of the River Clyde in Scotland as 'Hull No.534'. Due to the Great Depression work was halted in December 1931. With the aid of a government loan on condition that the Cunard and White Star Line's merged work resumed in April 1934, the great liner was launched on 26 September 1934 at a total cost of £3.5 million. To facilitate the launch safely the banks of the River Clyde were widened, the depth of the river was dredged and eighteen special drag chains were attached to check the speed of launch.

The name of the new liner had been kept a closely guarded secret and it was the intention of the Cunard White Star Line to name the new liner *Victoria*, in keeping with the tradition of naming ships ending with 'ia' or 'ic'. It is said that when His Majesty King George V was approached at Balmoral by the company's representatives to name the new ocean liner after Britain's 'greatest queen', he beamed with a broad smile and replied, 'Gentlemen, my wife will be delighted.'

The Cunard White Star representatives therefore had no choice but to name the hull of 534 *Queen Mary* after Her Majesty Queen Mary, the consort of King George V. Traditionally only capital ships of the Royal Navy had been named after sovereigns of the realm and the story was officially denied by company officials. However, behind closed doors at the captain's table on the 1936 maiden voyage of the *Queen Mary*, Sir Percy Bates, chairman of the Cunard White Star Line, confirmed that the story of the royal naming with the king at Balmoral was correct to *Washington Post* editor Felix Morley and attending members of the crew, including the *Queen Mary*'s Master Sir Edgar T. Britten.

The target for the maiden voyage was to take the Blue Riband award for the fastest transatlantic crossing. High speeds were continuously achieved but speed was drastically and frustratingly reduced on the final day owing to heavy fog. The designers of the rival French Line *Normandie* criticised the *Queen Mary* for being, '*trop traditionnel*'. My father often repeated that it was true to say that the *Queen Mary*'s Art Deco did appear to be conservative compared to the plush ultra-modern French rival's design, but he was quick to point out that the *Queen Mary* was far more popular in terms of passengers carried up to the start of the Second World War.

The whole of Southampton rejoiced in August 1936 when the *Queen Mary* captured the Blue Riband from the French Line *Normandie* with average speeds of 30.14 knots on the westbound voyage and 30.63 knots on the eastbound. Returning crew members from the *Mary* to Northam, Southampton, were cheered and hailed as heroes.

Daily log records. (Britton Collection)

Following the refit of the *Normandie* in 1937 with new propellers and a new lubrication system, she seized the Blue Riband back. This unwelcome news was met with almost disbelief in Southampton. In 1938 the *Queen Mary* was readied for an attempt to regain the Blue Riband and every boiler and piece of equipment was double-checked. The end result was that the *Queen Mary* won back the coveted award in both directions with average speeds of 30.99 knots westbound and 31.69 knots eastbound. This record was to remain unbeaten until 6 July 1952 when the streamlined 'racehorse of the Atlantic', the SS *United States*, finally took the Blue Riband. To this day, there is much heated debate in my family, who were crew members of the Cunard Queens, as to whether a further attempt on the Blue Riband would have been successful from either the *Queen Mary* or her sister the

Queen Elizabeth. In reality, listening to friends who were crew members on the United States and checking official log records reveals that the 'Big U' had even more speed to offer!

In late August 1939 the clouds of war loomed and the Queen Mary was escorted home to Southampton by HMS Hood. The Mary set sail from her home port for New York on 1 September, but by the time she arrived at her destination war had been declared by Neville Chamberlain. Consequently, the Queen Mary was instructed to remain in port tied up alongside her great rival Normandie. In 1940 they were joined by the newly completed Cunard Queen Elizabeth following her secret dash across the Atlantic.

On 1 March 1940, the Queens were conscripted by the British Government, camouflaged and painted in grey livery. With the combination of her new appearance and great speed, the Queen Mary obtained the nickname 'Grey Ghost'. She set sail for Sydney, Australia, on 21 March where her conversion was completed with an external degaussing coil around the hull to protect against magnetic mines. All internal fittings such as carpets, china, crystal, silver service, paintings and tapestries were placed into store for the duration and new wooden bunk fittings to accommodate up to 15,000 troops were installed in their place. Nazi Germany leader Adolf Hitler placed a bounty on the sinking of the Queen Mary to all U-boat submarine commanders, but she was too fast for them!

The German High Command directed the pocket battleship Lutzow (formerly named Deutschland) to 'find the Queen Mary and sink her'. On 7 April 1940 the 14,290-ton Lutzow with 1,150 men aboard set out at 28 knots to fulfil her orders in Operation Weserubung. The Royal Navy on learning of this hostile action deployed the submarine HMS Spearfish. On 11 April the British submarine managed to get a torpedo hit on the Lutzow resulting in the pocket battleship returning to Kiel for repairs.

On 5 May 1940 the Queen Mary embarked 5,000 Australian troops and transported them to Alexandria to reinforce the depleted garrison. Throughout the following year, Sydney Harbour was to become the Mary's home port conveying further servicemen to the Middle East. The entry of Japan into the Second World War presented a new threat to the Queen Mary from Japanese submarines and extra destroyer escorts were provided. During the winter of 1941/42, the Queen Mary's troop-carrying capacity was extensively increased in a secret visit to New York to enable her to carry in excess of 8,000 men. She returned to Australia packed with United States GIs, arriving at Sydney on 28 March 1942. During the voyage to Sydney she called at Rio de Janeiro to take on fuel, arriving at 10.39 on Friday 6 March. It was discovered by British Intelligence that a local clique of Nazi sympathisers were attempting to contact a U-boat

submarine pack. Prompt action with completion of the pumping of fuel and a change of course to Cape Town at full speed following a zigzag pattern resulted in the prized target eluding the enemy submarines.

Family member Uncle Norman Bissell, on board British battleship HMS Howe, recalls that because of the Queen Mary's size and speed she was very difficult to escort. He recollects in 1942 that the Queen Mary approached the Clyde with a division of GIs on board at a speed of 28.5 knots and was escorted by the British cruiser HMS Curacao. The standard procedure was for ships to follow a zigzag course when in the vicinity of German U-boats. Inexplicably on 2 October 1942 there was a miscalculation in the timing of the course and the Queen Mary sliced the Royal Navy cruiser in half, sinking her immediately. She struck the cruiser at an acute angle 11ft from its stern. The Queen Mary was under strict instructions not to stop. Sadly, over 300 lives were lost with only 100 survivors being picked up by escorting destroyers HMS Bramham and HMS Cowdray. The damage to the Queen Mary was only slight and many of the crew were unaware that a disaster had occurred. Makeshift remedial repairs were carried out on the Clyde, but more substantial repairs were completed at Boston in the United States.

In 1942 it was realised that the Queen Mary was inadequately armed against potential air attack, though she was equipped with Vickers and Lewis guns, plus a single 4in gun. The Admiralty responded to this by equipping the Queen Mary with Oerlikon and rocket-firing guns. A little-known fact is that whenever US troops were travelling on board they also mounted Gatling guns at strategic points as extra cover. A basic radar system and degaussing coil (heavy copper strips sheathed in rubber girdles) around the ship to protect against magnetic mines was fitted in 1942. The ship's lookouts were also equipped with captured German Zeiss binoculars.

On 5 August 1943 the Queen Mary conveyed the British wartime Prime Minister Winston Churchill to the Quebec Conference. Churchill wrote:

The Queen Mary drove on through the waves and we lived in comfort on board. As usual on these voyages, we worked all day long (200 staff, plus 50 Royal Marine guards). Our large cipher staff, with attendant cruisers to dispatch outgoing messages, kept us in touch from hour to hour. Each day I studied with the Chiefs of Staff the various aspects of the problems we were to discuss with our American friends, the most important of these was, of course, Overlord.

The following year on 5 September 1944, Churchill crossed the Atlantic again on the Queen Mary to Halifax, Nova Scotia. The Prime Minister's

name on the secret passenger list was Colonel Warden, which was Churchill's wartime pseudonym.

A rarely disclosed fact about the *Queen Mary* was that in 1943 she sailed east across the Atlantic on different voyages with over 18,000 captured German and Italian prisoners for internment for the duration of the war.

During the war the *Queen Mary* could make her port turnarounds within four days, with 15,000 troops being disembarked and new stores, oil and provisions loaded for the next consignment of service personnel. In these years the *Queen Mary* was divided for administration purposes into three sections, with three corresponding identity colours. Upon boarding the ship, American GIs were issued with colour identity tags according to the designated area aboard. There were two basic meals per day with six sittings and over 400 tons were consumed per voyage. During her war service, the *Queen Mary* carried over 800,000 passengers, covered half a million miles and was a troopship and a hospital ship. Finally, when peace was declared in Europe, she ended up conveying thousands of GI brides to the States.

War service took its toll on the *Queen Mary* and from 29 September 1946 to 31 July 1947 she was refitted and refurbished for passenger service, with the internal décor and fittings being reinstated. The *Queen Mary* was now prepared for the Cunard two-ship-weekly transatlantic service with her sister the *Queen Elizabeth*. She sailed on her first commercial voyage since the war on 31 July 1947. The *Mary* was now equipped with space to carry thirty-six cars and new modern facilities like Flavel cookers.

In January 1955 the *Queen Mary* responded to an SOS call from the 7,000-ton Panamanian-registered ship SS *Liberator* in the Atlantic. The radio message said:

> Two of our crew have fallen into the hatch. They are mortally wounded. Please ask ship with doctor.

The *Queen Mary* was approximately 323 miles away from the SS *Liberator* when the call was received, but Captain Donald Sorrell decided to immediately steam at full speed to reach the storm-tossed ship by 01.30 the following morning. The passengers aboard the *Queen Mary* were informed that the liner was responding to an emergency call and many stayed up to line the rails and watch the rescue attempt at first hand.

Captain Sorrell switched on the powerful search lights of the *Queen Mary* to illuminate the stricken vessel. He also manoeuvred the Cunard liner so as to act as a giant windbreak to shield the tiny lifeboat taking Mr Yates, the *Queen Mary*'s doctor, to the casualties. The lifeboat, under the

command of Senior First Officer Leslie Goodier with a crew of volunteers, took half an hour to reach the casualties. Upon arrival at the SS *Liberator*, Mr Yates and a sailor from the *Mary* managed to scramble aboard up the Jacob's ladder. Meanwhile, the lifeboat had to return to the *Queen Mary* because of the danger of capsizing.

A fresh volunteer crew returned to the stricken ship under the command of Chief Officer P.A. Reed. The casualties, doctor and *Queen Mary*'s sailor were all safely lowered into the lifeboat. The transfers to the *Queen Mary*, however, took six attempts and once aboard the injured men were taken straight to the ship's hospital. The passengers aboard the *Mary* broke out into spontaneous applause and a collection of a large sum of money was presented to the valiant volunteer lifeboat crews. This heroic act was also recognised by the Shipwreck and Humane Society who presented the volunteer crews with silver and bronze medals and a certificate of valour.

On 1 June 1955 industrial action hit the *Queen Mary*. Trouble had been brewing for some time in the catering department over conditions of work and living in the ship and during the speedy turnarounds in Southampton and New York. This resulted in 200 men walking off the ship in dispute, followed by one-tenth of the crew declining to sail to New York. The liner now became strikebound at New York. Cunard then took immediate legal steps to obtain a High Court injunction against the strikers. On 26 June the strike was called off, but it is calculated that this action cost £2 million and affected 15,000 transatlantic passengers.

At the beginning of 1957 the *Queen Mary* entered the King George V Graving Dock at Southampton twenty-four hours late owing to bad weather on the return voyage from New York. The six-week annual overhaul was extended to seven weeks due to preparations for the installation of the stabilizers. On Tuesday 5 March the *Mary* was moved out of the dry dock to 107 Berth facing down Southampton Water. At noon on the Saturday, the shipbuilding workers 'down tooled' and went on strike, claiming that the specified repairs had not been completed. Cunard maintained that by noon the liner was ready for sea and that she was due to sail with 910 passengers on 20 March. The Transport & General Workers Union supported the industrial action and the port of Southampton ground to a halt with 10,000 workers taking action.

In response, Cunard approached the British Government for assistance and with the aid of Admiralty tugs from Portsmouth Naval dockyard the *Queen Mary* sailed at 13.35. On the return voyage from New York, the secretary of the National Union of Seamen appealed to the strikers at Southampton to end their ban on the *Queen Mary*. On reaching Cherbourg the *Mary* tied up with passengers being transferred to the Cunard RMS

Ivernia for the cross-Channel trip to Plymouth, where special trains waited to transport passengers to London Waterloo. A fleet of Silver City Airline Bristol Super Freighter aircraft were hired at short notice to resupply the *Queen Mary* at Cherbourg. Cunard had won the dispute, but it cost the port of Southampton £10,000 in lost revenue.

In 1958 new Denny Brown stabilizers were fitted to the *Queen Mary* costing £500,000, one pair forward and one amidships, which proved to be a great success, dramatically reducing the rolling action of the ship.

Competition by the early 1960s was coming from air travel. In 1961 passenger numbers on the *Queen Mary* had dropped to as low as one-quarter of the ship's total capacity. Steward Bernard Webb recalls that there were significantly more crew aboard than passengers on occasions and remembers when Cunard sent the *Mary* on a Christmas cruise to Las Palmas in December 1963. Other cruises took place to the Mediterranean and Nassau, but she was limited by her inability to traverse either the Suez or Panama Canals. Cost cutting was implemented with the routine twice-yearly overhauls in the KGV Graving Dock reduced to one annual overhaul during the off-peak winter season. The May 1966 Seaman's Strike added to the problem with an estimated loss of revenue of £3 million for Cunard in six weeks.

By the end of the summer of 1966 rumours in Southampton were rampant regarding the future of the *Queen Mary* and her sister. The Cunard Chairman Sir Basil Smallpiece announced that the *Queen Mary* was losing £8,000 per day and both Queens were not paying their way. On 8 May 1967 Captain William Laws aboard the *Queen Mary* opened a letter from Sir Basil Smallpiece stating:

It is a matter of great regret to the Company and to me personally, as it will be to friends throughout the world, that these two fine ships, the *Queen Mary* and *Queen Elizabeth*, must shortly come to the end of their working lives.

The announcement was met on board by silence with crew members feeling utter shock and disbelief, for the *Queen Mary* had undergone a £1 million refit just months before.

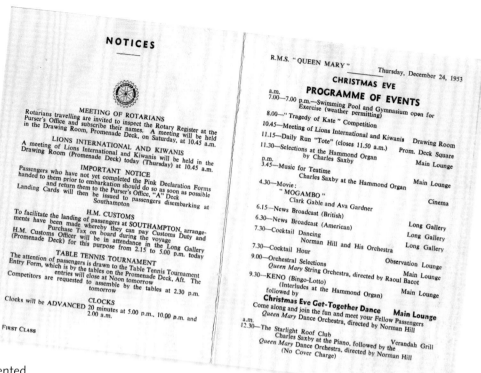

Programmes of events. (Britton Collection)

At this point the very future of the world's greatest liner was in doubt. The renowned scrap merchants Birds and Simms openly revealed that they would delight in cutting up the Cunarder. An eccentric proposal was put forward of welding together both Cunard Queens to form the world's largest catamaran! Another idea was to keep the Queen Mary in Southampton as a museum, floating university, hotel and tourist attraction. Sadly, the local British aristocrats just did not have the cash to fulfil this dream. Instead, the city of Long Beach, in southern California, made a successful sealed bid of $3,450,000 (£1,230,000) and the rest, they say, is history.

After the Queen Mary's last official voyage under Cunard and a two-week cruise to Las Palmas in October 1967, she was readied in Southampton for her 'Last Great Cruise' to Long Beach. The cost of a ticket for this last voyage aboard the Queen Mary was between $1,100 to $9,000 depending on the accommodation and level of travel. Captain Treasure Jones revealed that at the last moment the cruise to Long Beach was in danger of cancellation as the crew threatened strike action over bonus payments. The crew had demanded a bonus of £75 each, but settled for a £40 bonus just one hour before the boarding of passengers commenced. Even then some members of the crew were reluctant to sail on this long voyage and decided to stay at Southampton, resulting in a crew shortage aboard the Queen Mary.

Departing from 107 Berth in Southampton on 31 October 1967 for the final time with 1,093 passengers and 806 crew members, the whole city appeared to say goodbye.

As the Mary cast off, the Band of the Royal Marines played Auld Lang Syne and as the great liner headed away past the row of dock cranes, each nodded their jibs in sad tribute. The Queen Mary flew her 301ft paying-off pennant (10ft for each year of her service) and fourteen Royal Navy helicopters flew over her decks in anchor formation.

As the Queen Mary passed the exclusive Royal Yacht Squadron at Cowes on the Isle of Wight for the last time, a special signal was sent to the vessel:

We are sorry to say goodbye. Very best wishes.

The starting canon for the famous 'Round the Island' yacht races was also fired in tribute as the Mary passed up the Solent. In the English Channel, the Royal Navy aircraft carrier HMS Hermes passed and her whole

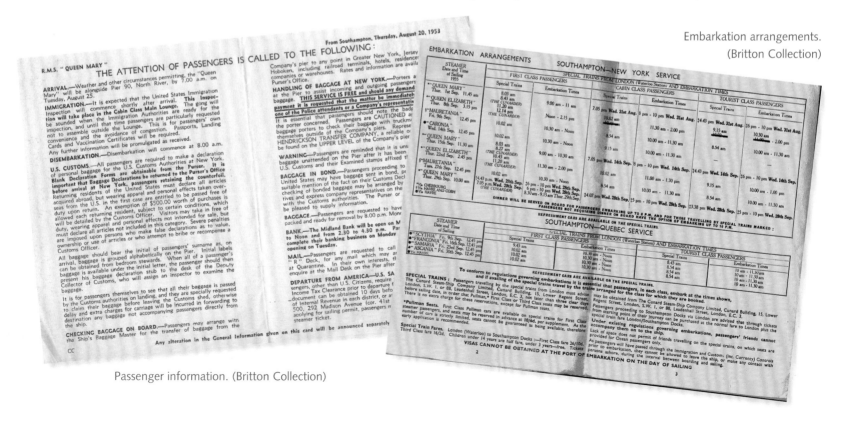

Embarkation arrangements. (Britton Collection)

Passenger information. (Britton Collection)

company lined the flight deck to raise their hats and cheer a traditional rousing salute.

The voyage to Lisbon in Portugal, her first port of call, was rough and took about two days through heavy seas. Whilst at Lisbon a stowaway, Stacy Miller, secretly slipped aboard, but was discovered before the *Mary* stopped at Las Palmas to take on 6,000 tons of fuel. Captain Treasure Jones now steamed the *Queen Mary* slowly at a steady rate of 20 knots to conserve fuel supplies. This resulted in the consumption of 550 tons of fuel per day, half the amount used whilst in transatlantic service. Upon arrival at Rio de Janeiro she had plied 3,540 miles and was refuelled with 2,440 tons. It was noted by the crew at Rio that the stock of *Queen Mary* marked cups had depleted so much owing to souvenir pilferage that they were reduced to paper cups in some parts of the liner.

As the ship sailed south radio communication with Cunard became very difficult. Eventually a clear message was received from Cunard instructing Captain John Treasure Jones, 'Get her there by yourself and don't try to contact us.' Captain Jones later revealed in a taped interview that, 'Cunard's instructions suited me fine. Being in sole charge of the *Queen Mary* was like having a wonderful and beautiful toy that you had to be very careful with.'

At mid-afternoon on Sunday 19 November 1967, amid great excitement, the *Queen Mary* rounded the treacherous Cape Horn. On board some privileged passengers sat on the red London Routemaster buses, which were being conveyed to Long Beach. Another passenger dived into the swimming pool so that he could claim to have swum around Cape Horn. Within minutes the calm weather began to change for the worse and the remainder of the voyage north up the west coast of South America continued to be rough.

The next stop was at Valparaíso on 23 November, having completed the longest section of the voyage totalling 3,895 miles. The penultimate leg took the *Mary* to Callao, where she took on a further 3,500 tons of fuel. By 5 December she was anchored off the fashionable resort of Acapulco. Here the crew took a well-deserved rest with shore leave. As the *Queen Mary* approached Long Beach, a DC-9 jet aircraft bombarded her with flowers reminiscent of her maiden voyage arrival at New York when a vintage propeller plane cascaded red roses from the air over the liner.

Forty days after departing from Southampton, she arrived at her final destination on 9 December 1967. She was welcomed triumphantly to her new home and the ship's last Master, Captain Treasure Jones, ceremoniously handed over the great liner's flags to her new owners, Mayor Wade and the city of Long Beach.

The Band of the Royal Marines play *Auld Lang Syne* as the *Queen Mary* makes her way down Southampton Water. As she passes by, each of the dock cranes nod, one by one, in tribute and fourteen Royal Navy Westland Wessex helicopters fly overhead in anchor formation. The Esso *Hythe*, uniquely dressed out as a tribute to the *Queen Mary*, follows the process on Tuesday 31 October 1967. (Britton Collection)

The final voyage, stopping off at Acapulco, December 1967. (Commodore G.T. Marr)

2

POST-WAR MEMORIES OF THE RMS *QUEEN MARY*

The *Queen Mary* returned to Southampton from Halifax, Nova Scotia, at the end of her final trooping voyage on 29 September 1946. She was demobilised, having carried 810,730 passengers, the majority of whom were servicemen, during her national service. Twelve hundred skilled workers from John Brown's shipyard on the Clyde now came aboard whilst the *Mary* was in the KGV Graving Dock to restore her to her former glory. They dismantled all equipment that had been fitted for wartime service and fitted a replacement stem following the collision with HMS *Curacao*. Furniture from the great liner that had been placed into store during the war at New York and in the New Forest was now lovingly restored and returned to the *Mary*.

Commodore Geoffrey Marr recounted to me the day the *Queen Mary* ran aground at Cherbourg, when he was serving as First Officer. He said that the liner had just completed her annual overhaul in the KGV Graving Dock in Southampton. She sailed on New Year's Day 1949 under the command of Captain Harry Grattidge who was making his first voyage in command of the *Mary*.

At 13.00 the *Queen Mary* set sail from Southampton in a fierce squall with the threat of a deep depression approaching from the west of Ireland. Two extra tugs came to assist the *Mary* sail having completed their set tasks with a Union Castle ship. The great liner had a rough cross-Channel passage and Geoffrey Marr remembered that they were accompanied by the Cherbourg pilot on the bridge who had joined the *Queen Mary* at Ocean Dock. Captain Grattidge was not keen to enter Cherbourg Harbour, but was reassured by the French pilot that once inside the liner would be protected and shielded from the bellowing wind by the land. After tendering the passengers, it was time to set sail again at 20.30. However, Geoffrey Marr recalled that whilst he was standing on the

Mary's forecastle, the wind direction changed and now veered SSW with increased strength. The orders were received 'to weigh the anchors', but in the violent rain and penetrating wind it was becoming difficult to stand let alone haul in the anchors. It became apparent that the *Queen Mary* was not manoeuvring correctly and she was in real trouble. The gale began to force the *Mary* towards the eastern end of the harbour where the water was shallow. In desperation the French pilot ordered that the starboard anchor should be immediately dropped with the hope that this action would prevent her drifting and enable the ship to safely swing around.

With the French pilot now in almost total despair, Captain Grattidge stepped in and assumed command. He decided that the only way to get the *Mary* out of the harbour under such treacherous conditions was to manoeuvre astern and he gave the order to 'weigh the starboard anchor'. First Officer Geoffrey Marr attempted to follow this order, but soon realised that when the capstan started, the cable was only coming in very slowly and that the anchor was fouled. This was confirmed when the anchor approached the water's edge and it was observed that it had picked up two heavy wire cables. It was later discovered that these were the remains of the armoured section of the wartime PLUTO (pipeline under the ocean) which was used to supply the Allied forces after D-Day. With the engines now engaged there was suddenly a bump right aft. The *Queen Mary* had grounded on a pinnacle rock just to the southward of the western entrance to Cherbourg Harbour. No attempt was made to move the liner until high tide at 8 a.m. the next morning. With the assistance of local and naval tugs, the ship was safely eased off and returned to Southampton for examination and remedial repairs.

Commodore Geoffrey Marr related to me an amusing anecdote of an incident which occurred when he was serving on the *Queen Mary* in 1951.

Prime Minister Winston Churchill was on board the *Queen Mary* on a transatlantic voyage to visit US President Truman. He was accompanied by three Cabinet ministers: Foreign Secretary Anthony Eden, Paymaster General Lord Cherwell and Secretary for the Commonwealth Relations Lord Ismay, plus a staff of forty-odd civil servants. Additional telephones were installed on the *Queen Mary* to ensure constant contact with London. The sailing of the *Mary* from Ocean Dock, Southampton, was delayed for twenty-four hours as the port anchor had jammed in a hawse pipe.

Soon after sailing Commodore Marr, then a Staff Captain on the *Queen Mary*, was about to enter the Churchill Suite when he was startled to hear from the other side of the door the strains of *Rule Britannia*. After knocking and entering he witnessed the Prime Minister conducting with his cigar a choir of three Cabinet ministers and the civil servants. Suitably lubricated with a glass of scotch, the singing continued with renditions of Harrow School songs.

In July 1952 the *Queen Mary* lost the coveted Blue Riband to the SS *United States* which was making her maiden voyage across the Atlantic. The record for the fastest transatlantic crossing was comfortably taken. The streamlined American liner performed to all expectations in heavy swells and for a time exceeded 36 knots. Crossing the finishing line at Bishop's Rock, England, the SS *United States* had easily achieved the record held for fourteen years by the British Cunard RMS *Queen Mary*, arriving in an unprecedented three days, ten hours and forty minutes. On the return westbound maiden Voyage 1, Captain Manning on the SS *United States* pointed the liner's streamlined bow back towards New York and once again broke all former records, arriving in New York in three days, twelve hours and twelve minutes, with an average speed for the westbound crossing of 34.51 knots. There was a great feeling of disappointment on the *Queen Mary* and the realisation that a new challenge was out of the question.

Captain Donald Sorrell related to my father and I an anecdote regarding the voyage on the *Queen Mary* of Her Majesty Queen Elizabeth, the Queen Mother, in November 1954. This story was also confirmed by Commodore Marr. HM the Queen Mother was returning from New York to Southampton on the *Queen Mary* following an official visit. The Cunard Line decided that the Senior Officer of the shipping line, Commodore Sir Ivan Thompson, normally based on the *Queen Elizabeth*, should take over command of the *Queen Mary* from Captain Donald Sorrell, who was the regular captain of the *Mary*. When the crew of the *Queen Mary* learned of this news there was outrage on board. In response, Donald Sorrell related that the crew organised a signed petition against this decision, with the words:

> We consider that in view of the way Captain Sorrell has handled things in the past he should by right stay on board and command the liner on the return of the Queen Mother.

Captain Sorrell said that while the *Queen Mary*'s crew felt no disrespect to Commodore Thompson, they felt that the situation was an insult to their captain. Diplomatically Donald Sorrell spoke to representatives of the crew and persuaded them to serve under Commodore Thompson.

Donald Sorrell first shot to fame as relieving captain on the *Queen Mary* in 1953 when he famously docked the liner without the aid of tugs or a docking pilot in New York. Captain Sorrell said that the night prior to

Poems. (Britton Collection)

Mary Magnificent

For thirty-one years you have sailed the Atlantic,
A magic blue circle your pasture,
In fair weather, foul weather, wind blowing frantic,
Surviving a war of disaster.

Age has not scarred you or sullied your beauty,
Your stamina knows no decay,
And your thirty-knot speed is as much as you need
To compete with the best of today.

You've carried the famous, the infamous too,
And those unattuned to the sea,
And hordes of just everyday, commonplace folk,
Nonentity people like me,

But you'll soon be retired as no longer required,
For you're uneconomic they say,
Your friends are all horrified, Mary old girl,
But sentiment won't pay your way.

So you and Q.E. must abandon the sea,
But passengers now in their teens,
As time passes by will recount with a sigh,
The legend of Cunard's two Queens.

Mrs. C. Gowing

The Mary

Remember her with nostalgic awe,
The happiest ship ever, to the core,
She answered the call in Britain's need,
Thwarting enemy subs with nimble speed.

Transporting troops to lands afar,
Earning the 'Atlantic,' 'Pacific' and 'Burma' Star,
To injured seamen broken in fall,
She dashed to their rescue at the S.O.S. call.

The time has come for this Old Beauty,
To retire her from Atlantic duty,
When she sails off to Long Beach in atmosphere terse,
She will 'finish with engines,' her grand crew disperse.

The toast is "The Queen," the end of an era,
Here's to the "Mary," the greatest ship ever.

Joe Allen

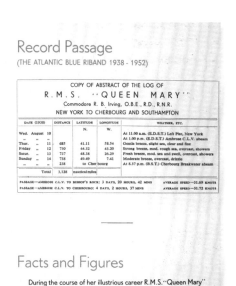

Record Passage
(THE ATLANTIC BLUE RIBAND 1938 - 1952)

COPY OF ABSTRACT OF THE LOG OF

R.M.S. ''QUEEN MARY''
Commodore R. B. Irving, O.B.E., R.D., R.N.R.
NEW YORK TO CHERBOURG AND SOUTHAMPTON

DATE (1938)		DISTANCE	LATITUDE N.	LONGITUDE W.	WEATHER, ETC.
Wed. August	10				At 11.00 a.m. (E.D.S.T.) Left Pier, New York
" "	"				At 1.00 p.m. (E.D.S.T.) Ambrose C.L.V. abeam
Thur. "	11	685	41.11	58.54	Gentle breeze, slight sea, clear and fine
Friday "	12	730	44.32	43.20	Strong breeze, mod. rough sea, overcast, showers
Satur. "	13	737	48.38	26.29	Fresh breeze, mod. sea and swell, overcast, showers
Sunday "	14	738	49.49	7.41	Moderate breeze, overcast, drizzle
" "	"	238		to Cherbourg	At 6.37 p.m. (B.S.T.) Cherbourg Breakwater abeam
	Total	3,128	nautical miles		

PASSAGE—AMBROSE C.L.V. TO BISHOP'S ROCK: 3 DAYS, 20 HOURS, 42 MINS — AVERAGE SPEED—31.09 KNOTS
PASSAGE—AMBROSE C.L.V. TO CHERBOURG: 4 DAYS, 2 HOURS, 37 MINS — AVERAGE SPEED—31.72 KNOTS

Facts and Figures

During the course of her illustrious career R.M.S. "Queen Mary" steamed over 3,795,000 nautical miles; carrying more than 2,115,000 fare paying passengers. In World War II she transported nearly 1,000,000 allied troops, and in doing so, it is claimed, was instrumental in shortening the War by one year.

THE CUNARD STEAM-SHIP COMPANY LIMITED.

SPECIAL TRAIN
Date...Nov. 5. Time 9.02a~
RESERVED SEATS
WATERLOO STATION, LONDON TO SOUTHAMPTON
connecting with Ship...Queen Mary.

YOUR SEAT IS 2-0 CLASS	NUMBER OF SEATS RESERVED 3
RESERVED IN 104	INDICATED ON THE WINDOW OF THE COMPARTMENT
COMPARTMENT No.	

NOTICE—In order to save delay to passengers on the Dock at Southampton, the Inspection of Passports and Steamer Tickets is carried out by the Cunard Line Representatives on the special train, and passengers are requested to have their Passports and Steamer Tickets conveniently available for this purpose.

L.P. 40/793.

R.M.S. "Queen Mary"

Captain J. W. Caunce, R.D., R.N.R.

presents his compliments

and requests the pleasure of your company

in the Main Lounge (Starboard Side)

on Saturday, June, 25, 1960, at 12-15 p.m.

(Entrance Promenade Deck Square)

Special train ticket and invitation to the captain's table. (Britton Collection)

ABSTRACT OF THE LOG OF THE CUNARD STEAM-SHIP COMPANY LIMITED

R.M.S. "QUEEN MARY"
CAPTAIN D. W. SORRELL

SOUTHAMPTON AND CHERBOURG TO NEW YORK

Date (1953)	Dist.	Latitude N.	Longitude W.	Weather, etc.
Sunday, Feb. 1				At 11.45 (G.M.T.) left Ocean Terminal, So'ton
,, ,, ,,				At 13.45 (G.M.T.) NAB Tower abeam
,, ,, ,,				At 17.45 (G.M.T.) arrived Cherbourg
,, ,, ,,				At 20.36 (G.M.T.) left Cherbourg,
Monday, ,, 2	468	49.53	13.38	Mod. gale, rough sea, heavy swell, o'cast & clear
Tuesday, ,, 3	721	48.08	31.48	Light breeze, mod. sea & swell, cloudy & clear
Wed., ,, 4	722	43.48	48.02	Light breeze, slight sea, mod. swell, cloudy, clear
Thursday, ,, 5	684	41.43	63.07	Mod. gale, rough sea, heavy swell, o'cast & clear
Friday, ,, 6	495	to Ambrose	Chan. L.V.	At 06.00 (E.S.T.) Ambrose Channel L.V. abeam. Arrival
Total	3,090	nautical miles		

| PASSAGE—4 days, 14 hours, 24 minutes | AVERAGE SPEED—27.99 knots |

Log abstract. (Britton Collection)

entering New York he had received a message asking if it was possible to steer the *Queen Mary* into New York and dock her at Pier 90 without the traditional aid of tugs or a pilot. 'Certainly, I will be delighted,' he replied. For five days the whole of the port of New York had been paralysed by the strike of 3,500 tug men who were seeking a pay rise. Captain Sorrell revealed that for years he had considered three methods as to how he would dock the *Queen Mary* unaided if ever required. With the quayside packed with over 2,000 spectators watching and anticipating disaster, the *Queen Mary* headed cautiously up the fast-flowing River Hudson with its challenging tides. There was also the risk of strong gusts of wind which could have a tremendous effect on the sheer size of the liner. Amongst the crowd were many of the striking tug men who could quickly identify any signs of trouble with their wealth of experience. As the *Queen Mary* approached Pier 90 even the traffic on the highway stopped. Everyone waited nervously, many with cameras at the ready.

Captain Sorrell remembered that the morning was hot and muggy, but the crucial factor was that there was little if any wind. To assist him with the precise navigation of the liner, he had to hand his wooden set square with a semicircle of screws on top. A lifeboat from the Cunard *Caronia* was sent out to assist with docking lines and, with the tide right, Captain Sorrell began to manoeuvre the *Queen Mary* towards the entrance to Pier 90. At 09.50 the *Mary* began to slowly pass the end of the pier. A minute later the lifeboat from the *Caronia* caught a mooring line and this was quickly secured to the end of Pier 90. All appeared to be going well, but Captain Sorrell recalled that he suddenly felt the underwater currents of the River Hudson grip the stern of the liner and swing it dangerously towards the pier. To counter this Sorrell ordered, 'Back all go astern' and with one whistle she responded immediately. 'I backed out in a hurry,' the smiling Captain Sorrell recollected.

Plan 2 now went into action. Captain Sorrell waited for slack water between the tides and to do this he observed the movement of driftwood and debris in the River Hudson. Checking with his homemade navigation square, he noted down readings and decided it was time to lower the port anchor. He revealed that his plan was to use the tide to his advantage. He was going to use the corner of the pier as a pivot, lay the liner prow on it, and bend the *Queen Mary* round, using the current to ease the stern around. He commenced this operation at 10.10 and within minutes the bow had been secured to allow the *Queen Mary*'s capstans to pull them taut. At this point Captain Sorrell felt a great surge of relief for within five minutes the great liner was making progress into the slip. A further five minutes passed and a line astern had been secured and further lines

were attached. Captain Sorrell concluded his memory by mentioning that the 976 passengers who were lining the rails to watch the hazardous docking suddenly burst into spontaneous applause and began cheering. The Quartermaster Ken Furr and officers congratulated him and shook his hand. Going out onto the flying bridge Captain Sorrell noticed that a strong southerly wind had sprung up; had it done so just minutes earlier it would have potentially caused a great disaster.

Captain Donald Sorrell modestly stated that no one could have guessed how much worldwide publicity this would generate and the following twenty-four hours after the docking were the most hectic of his life, with requests for radio, television and newspaper interviews. Captain Sorrell also sailed unassisted from New York. The full story of these events was related many times to patients receiving fillings in the dentist chair by Donald Sorrell's son who was a Southampton dentist.

The Duke and Duchess of Windsor travelled regularly on the *Queen Mary* in the early 1950s. The brother of my Uncle Joe, Bernard Webb, was a steward on the *Mary* and retold many amusing encounters with the Windsors. The duchess used to confine herself to her suite, but would summon Bernard Webb to undertake the regular duties. Bernard recalled that she would point at things and click her fingers rather than speak directly. The Windsors' dogs would be kennelled at nights but after a walk around the ship they would be delivered to the Windsors' suite.

Commodore Donald MacLean related that when he worked aboard the *Queen Mary*, the Duke of Windsor would often call into the bridge in the middle of the night or when the English coast came into view. He remembered that the duke was a quiet, well-spoken person who appeared to be very happy in the all-male atmosphere of the bridge. By the mid-fifties the Windsors had transferred their patronage to the new Blue Riband winner SS *United States*. The reasoning for this did not become apparent until later: it was discovered that the Windsors were given preferential treatment with their fares and provided with an exclusive suite when they travelled aboard the United States Lines flagship.

One major problem with both the *Queen Elizabeth* and *Queen Mary* was stability when bad weather was encountered on the Atlantic. The rolling of the ships was the source of constant complaints from passengers. Commodore Marr explained that this problem was resolved on the *Queen Mary* in 1958 with the fitting of Denny Brown stabilizers at Southampton in the KGV Graving Dock. This lengthy operation cost Cunard approximately £500,000, but it was a sound investment as it halted the drift of passengers away to the rival SS *United States* which was equipped with stabilizers, although not so luxurious. Commodore

Marr revealed that the proving trials for testing the stabilizers in the English Channel were an amusing affair. A forced roll where the *Queen Mary* was deliberately manoeuvred to sway was witnessed by a fishing boat. Before the stabilizers could be deployed the skipper of the fishing boat radioed through to enquire if everything on the *Mary* was OK. With the stabilizers deployed the smoothness of the ship was transformed.

By 1961, passenger numbers dramatically dropped owing to fierce competition from transatlantic air travel. Commodore Marr admitted that on some winter voyages there was as few as a quarter capacity of passengers, yet the *Mary* retained a full crew. Steward Bernard Webb stated that the ratio of crew to passengers was at times 2:1. The management of Cunard built in economy measures by dispensing with the summer overhaul of the liner, leaving just one off-peak annual winter overhaul. Additionally, a decision was made to operate the *Queen Mary* on cruises, the first of which was Voyage 425 from Southampton to Las Palmas. In subsequent years the *Queen Mary* went on cruises to the Bahamas and Mediterranean. Bernard Webb revealed that these cruises were sometimes unbearably hot for crew and passengers due to the lack of air conditioning on board.

On 1 October 1963 the manoeuvre of docking the *Queen Mary* without tug assistance at New York was successfully repeated, this time by Captain Sidney Jones.

After taking over the command of the *Queen Mary* in November 1965, Commodore Marr revealed that he initially sailed on a routine voyage across the Atlantic. This was followed by two cruises to Nassau. The highlight of the first cruise was the Annual Convention of the United States Navy League, which was held aboard the *Mary*. Commodore Marr said that several members visited the bridge and went on a behind-the-scenes tour to explore the engine room. Finally, members of the League presented themselves at dinner wearing their dress uniforms, liberally covered in gold braid and medals. This was not only dazzling, it was also quite overwhelming. The vivid memory of Commodore Marr's second cruise was of the morning of Thursday 25 November at Nassau when film crews descended on the *Queen Mary* to shoot footage for a Frank Sinatra film, *Attack on a Queen*.

Before sailing from Southampton for the next routine transatlantic voyage on 8 December, Commodore Marr recalled that he was alerted to the threat of a westerly gale and received reports of an SOS message from the Greek ship SS *Constantis*. The SOS distress signal stated that the ship was 365 miles west of the *Queen Mary* and in danger of sinking. As the day progressed, Commodore Marr received regular reports from ships

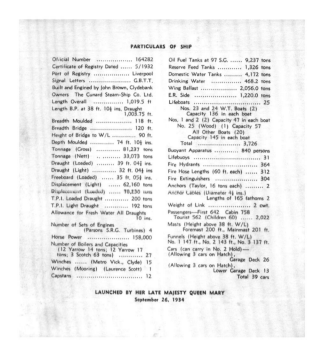

Far left: Ship's particulars. (Britton Collection)

Left: 1964 fares. (Britton Collection)

responding to the SOS call and at one point an attempt was made to abandon ship with their lifeboats severely damaged and two members of the Greek crew thrown into the stormy seas. After clinging on to a life raft, the two crew members were rescued by the SS *Stove Vulcan,* but sadly the radio officer died shortly afterwards.

At 17.00 Commodore Marr altered course on the *Queen Mary* to deviate 50 miles south towards the stricken Greek ship. The passengers on the Cunard liner were informed and they eagerly lined the rails to observe proceedings. The *Queen Mary* arrived on the scene at 20.00 to find that four other ships were present with an RAF Shackleton aircraft circling overhead. The presence of an illuminated, vast ocean liner appeared to be a calming reassurance to the Greek captain. At 21.49 Commodore Marr received a message from the captain of the SS *Constantis* to say that he and his crew were abandoning ship and requesting assistance from the *Queen Mary*. Commodore Marr immediately responded by instructing the Greek captain and his crew to remain on board as there was little that the *Queen Mary* or any other vessel present could do owing to the severity of the seas.

With the SS *Constantis* in no danger of sinking and other vessels present to assist, Commodore Marr radioed the Greek captain at 23.11 to inform him that the *Queen Mary* was resuming its voyage to New York. However,

the Greek captain responded by saying that if the *Queen Mary* left the crew would be forced to abandon ship. Realising that the psychological presence of the 82,000-ton *Queen Mary* provided confidence and reassurance to the Greek ship, Commodore Marr decided to remain at the scene until the next morning. By 06.00 German salvage tugs notified the *Queen Mary* that they were heading at full speed to the scene, so at 08.00 the *Queen Mary* resumed her voyage to New York.

Commodore Marr revealed that the story did not finish there as the *Queen Mary* had strained her fuel reserves to the limit. It was normal practice to leave Southampton with enough Bunker C fuel oil for the voyage to New York plus a surplus for one day of spare in the tanks. The reasoning behind this was that as fuel was cheaper in the USA, they would fill up at New York and just top up at Southampton. The problem now confronting the *Queen Mary* was that the fuel supply had dwindled to the bare minimum. In order to economise on the fuel, the speed of the *Queen Mary* was reduced, making her arrival at New York thirty-six hours late. Normal consumption of fuel on the *Queen Mary* was 1,200 tons per day. As the ship docked at Pier 90 at the end of this epic voyage there remained less than 300 tons of fuel on board. Much of this was considered as unpumpable sludge at the bottom of the tank! Commodore Marr confided that the ship had arrived at New York on a prayer.

Returning to Southampton the *Queen Mary* set out on a Christmas Cruise to Las Palmas chartered by the *News of the World* Sunday newspaper. As the *Queen Mary* reached the Bay of Biscay she hit a Force 9 gale with dangerously rising seas, causing her to lift and roll. The ship was full, with 1,200 passengers on board including the chairman of the *News of the World* and deputy chairman of the Cunard Line. At 13.38 the ship caught an enormous hurricane-force wave on the starboard shoulder. The impact of this wave lifted the top off a cowl ventilator weighing over a ton on the forward end of the promenade deck. The massive piece of metal whisked into the promenade deck windows, completely smashing two of them. These windows were ¾in-thick armoured glass, protected by closed steel shutters from the night before. At the very moment of impact a father and his son were walking past on the other side of the window. Fragments of glass severely injured the father in particular, but they both soon recovered. By 21.00 the storm had passed and life on board the *Queen Mary* returned to normal.

The year 1966 was to be the last full year of service for the *Queen Mary*. Red Funnel tugboat captain Peter Davidson of the *Hamtun* recalled that it could have been the last year for the crew of the tugboat, too. The *Hamtun* had been routinely assisting with the docking of the *Queen Mary* and was attached by a thick rope to her. After successfully swinging the ship into Ocean Dock, a great gust of wind caught the side of the ship and instead of pushing it into position, the Red Funnel tug now found herself being dangerously pulled with water coming over into the deck. Captain Davidson frantically called to the *Queen Mary* to 'Let go and detach the rope', but the crew failed to respond. By now all was safe and secure with the *Queen Mary* who commenced unloading, but the *Hamtun* was still attached to the liner. Out of frustration, Captain Davidson scrambled up the rope and climbed aboard the *Queen Mary*. There, to his surprise, he discovered that the crew had completely overlooked the fact that the tug *Hamtun* was still attached. The red-faced officers and crewmen of the *Queen Mary* profusely apologised and made recompense with a lavish meal for all the tug's crew.

On 24 September 1967 Commodore Geoffrey Marr, who had transferred as Commodore of the Cunard Line to the *Queen Elizabeth*, telegrammed Captain Treasure Jones on the *Queen Mary* to commemorate the final transatlantic passing of the two Cunard Queen liners: 'It is a sad moment as these two great ships pass for the last time.'

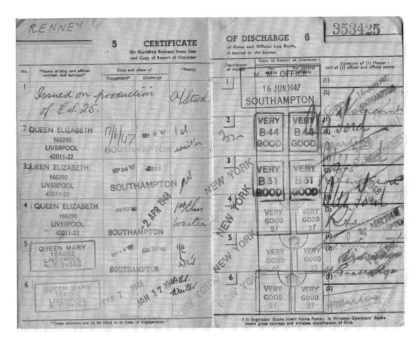

Certificate of discharge. (Britton Collection)

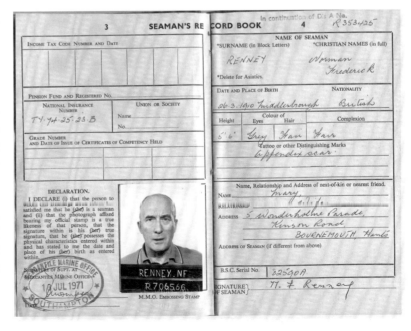

Seaman's record book. (Britton Collection)

3

THE CAPTAINS

Captains with registered legal command of the *Queen Mary* 'prescribed from Southampton Custom House amendments of Master C344B'. (By kind permission of Cunard)

NAME	DATE OF FIRST COMMAND OF RMS *QUEEN MARY*
Commodore Sir Edgar T. Britten	1 December 1935
Captain George Gibbons	29 January 1936
Commodore Reginald V. Peel	4 August 1936
Commodore Robert B. Irving	11 November 1936
Captain John C. Townley	30 March 1937
Captain Peter A. Murchie	19 April 1938
Captain Ernest M. Fall	9 April 1941
Commodore Sir James Bisset	23 February 1942
Commodore Sir Cyril G. Illingworth	10 August 1942
Captain Roland Spencer	29 July 1944
Commodore Charles M. Ford	11 March 1946
Commodore George E. Cove	6 December 1946
Commodore Sir C. Ivan Thompson	15 February 1947
Captain John A. MacDonald	6 March 1947
Captain John D. Snow	4 July 1947
Commodore Harry Grattidge	31 December 1948
Captain Harry Dixon	20 July 1950
Captain Robert G. Thelwell	13 August 1951
Captain Donald W. Sorrell	19 August 1952
Commodore George G. Morris	27 June 1956
Commodore Charles S. Williams	25 June 1957
Captain Alexander B. Fasting	11 September 1957
Captain Andrew MacKellar	26 August 1958
Commodore John W. Caunce	22 October 1958
Commodore Donald M. MacLean	24 June 1959
Captain James Crosbie Dawson	30 March 1960

NAME	DATE OF FIRST COMMAND OF RMS *QUEEN MARY*
Captain Sidney A. Jones	25 May 1960
Commodore Frederick G. Watts	9 August 1960
Captain Eric A. Divers	19 June 1962
Commodore Geoffrey T. Marr	7 May 1964
Captain John Treasure Jones	8 September 1965
Captain William E. Warwick	15 September 1965
Captain William J. Law	3 May 1967
Captain John Treasure Jones	In command for final round-trip voyage, 16 September 1967 to 27 September 1967, and for the final voyage round Cape Horn to Long Beach, CA, 31 October 1967 to 9 December 1967. Captain Jones officially handed the *Queen Mary* over to Long Beach on 11 December 1967, and the registry of RMS *Queen Mary* was cancelled: 'Certificate of Registry cancelled under Section 49 Merchant Shipping Act 1894'.

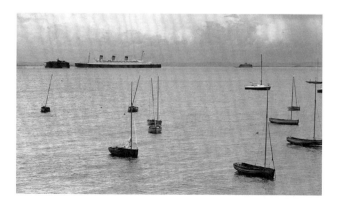

The inbound RMS *Queen Mary* passes the Spithead between Ryde and Portsmouth. (R.J. Blenkinsop)

PHOTOGRAPHIC RECORD

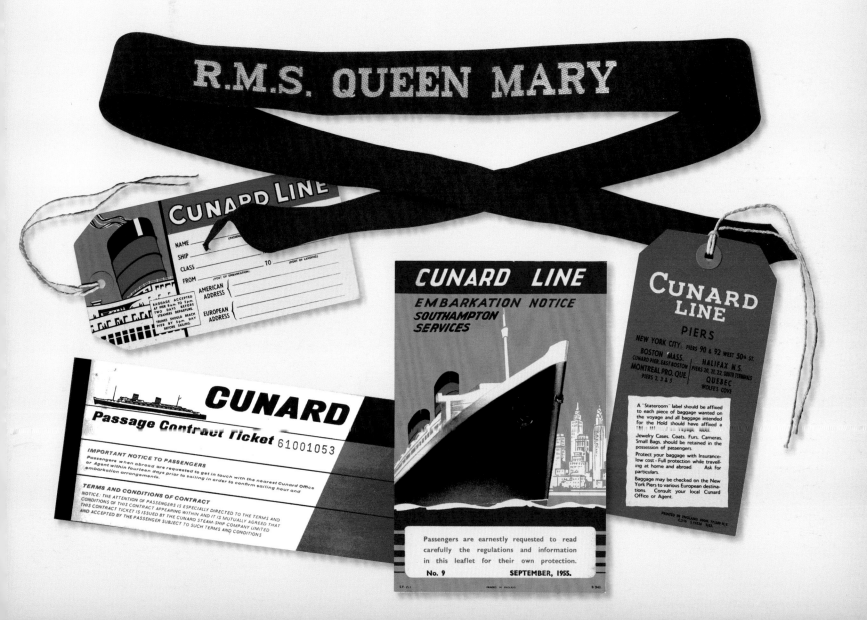

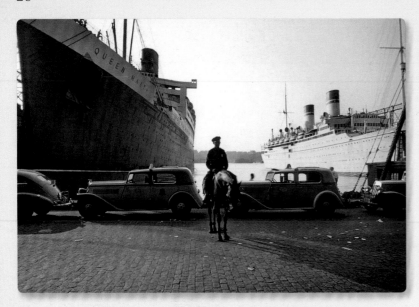

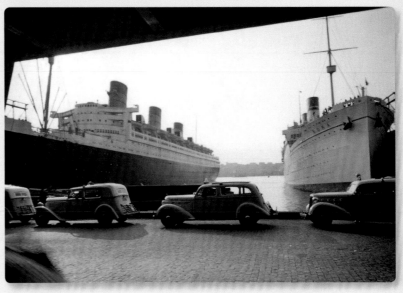

4 September 1939 finds the *Queen Mary* guarded by the New York Police at the Cunard Pier 92. She remained tied up here alongside her rival, the French Line *Normandie*, with her future uncertain. On the right of the picture is the Italian Line ship SS *Roma*. (Britton Collection)

Another original view, taken at the outbreak of the Second World War on 4 September 1939, shows a line of New York Police cars screening the *Queen Mary* at Pier 92 and the Italian Line *Roma* tied up in the adjacent pier. (Britton Collection)

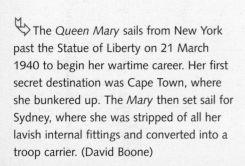

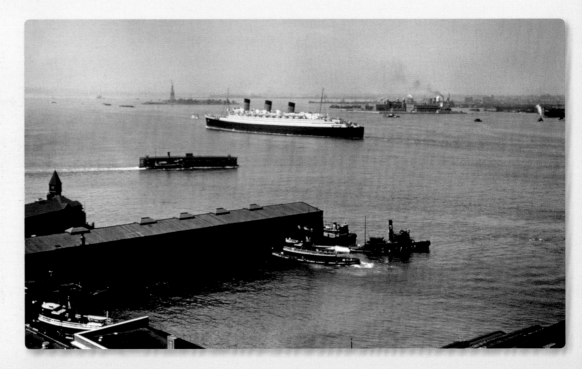

The *Queen Mary* sails from New York past the Statue of Liberty on 21 March 1940 to begin her wartime career. Her first secret destination was Cape Town, where she bunkered up. The *Mary* then set sail for Sydney, where she was stripped of all her lavish internal fittings and converted into a troop carrier. (David Boone)

Here we see the *Queen Mary* in her grey livery entering New York with the Statue of Liberty in the background. The 'Grey Ghost', as the *Queen Mary* became known, quickly had a bounty of 250,000 Deutschmarks placed on her, offered by Adolf Hitler to the German U-boat captain who sunk her. (David Boone)

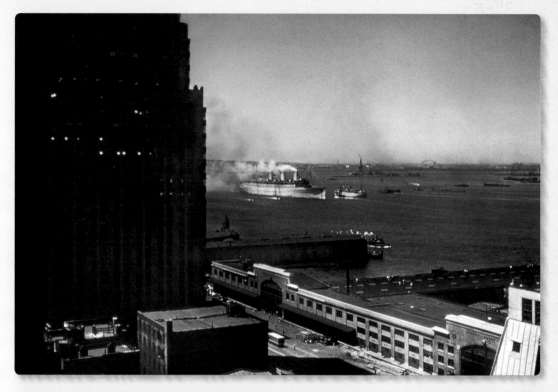

The *Queen Mary* is seen entering New York on VE Day, 1945, packed with GI brides. (David Boone)

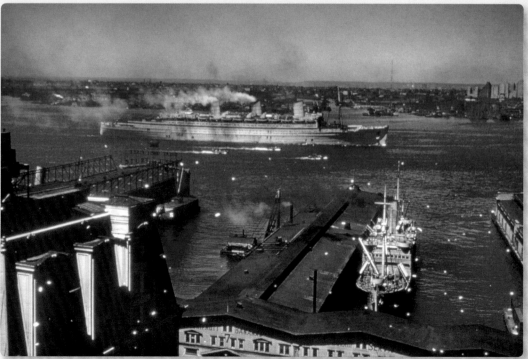

Queen Mary Captain Sir Cyril G. Illingworth made the front cover of *Time* magazine. Commodore Illingworth first captained the *Queen Mary* on 10 August 1942. (*Time* magazine)

RMS *Queen Mary* sailing brochure. (Britton Collection)

R.M.S.

"QUEEN MARY"

Quadruple-Screw Turbine ... Gross Tonnage 81,235

LIST OF OFFICERS

Captain — G. E. COVE

Staff Captain—A. MacKELLAR, R.D., R.N.R.

Chief Engineer.........A. S. FISHER	Chief Officer............G. T. MARR, D.S.C., R.D., R.N.R.
Staff Chief Engineer...D. McLELLAN	Purser.................A. J. HURLEY
Principal Medical Officer J. B. MAGUIRE, M.B., B.CH.	Staff Pursers... { D. C. CONNOLLY / T. HIDDERLEY
Surgeon F. G. MUNDELL, M.B., B.S.	Tourist Purser.........P. A. DAWES
Chief Steward.... G. N. WHITAKER	Chief Tourist Steward.........H. R. TWIST

Travel Bureau.....................E. ALDERSON

Tourist Travel Bureau..............S. BROWN

Cunard White Star Cunard White Star

Selection of menus and colourful menu covers. (Britton Collection)

R.M.S. "QUEEN MARY" Sunday,

. Dinner .

Juices : Tomato Grape Fruit

Chilled Melon

Hors d'Œuvre, Variés

Olives—Queen and Ripe Salted Mixed Nuts

SOUPS	Consommé Célestine	Crème St. Louis
	Cold : Vichysoisse	
FISH	Poached Halibut, Sauce Vin Blanc	
	Fried Fillet of Flounder, Tartare Sauce	
FARINACEOUS	Rizotto, Piémontaise	
VEGETARIAN	Savoury Vegetable Pie	
ENTRÉE	Tête de Veau en Poulette	
JOINT	Roast Leg and Shoulder of Lamb, Mint Sauce	
RELÈVE	Roast Turkey, Cranberry Sauce	
GRILL (to order)	Fillet Steak, Béarnaise	
VEGETABLES	Green Peas	Corn on the Cob
POTATOES	Boiled, Roast and Duchesse	
COLD BUFFET	Assorted Cold Meats	
SALADS	Tomato Lettuce Mixed Bowl Escarole	
DRESSINGS	Cream Vinaigrette	
SWEETS	Sans Souci Pudding Peach Melba	
ICE CREAM	Vanilla Pineapple Burnt Almond	

Fresh Fruit

Coffee (Hot or Iced)

Red and White Bordeaux — per Bottle or en Carafe, 5/-; per Glass, 1/-

C C

R.M.S. "QUEEN MARY" Friday, April 17, 1953

. Luncheon .

Juices: Tomato Sauerkraut

Consommé Ailerons Boston Clam Chowder

Split Pea Soup

Fillet of Striped Bass, Mirabeau

COLD: Salmon, Mayonnaise

Macaroni au Parmesan

Welsh and Yorkshire Rarebits

Braised Ox Tail with Spring Vegetables

Roast Stuffed Shoulder of Veal, Portugaise

Green Lima Beans Mashed Turnips

Purée and Lyonnaise Potatoes

GRILL (to order): Loin Lamb Chop, Fleuriste

COLD: Boiled Ham Ox Tongue Roast Beef

Fresh Brawn

Salads: Lettuce Beetroot Cucumber

French and Russian Dressings

Blueberry and Apple Pie

Ice Cream

Cheese: Brie Cheddar

Tea Coffee

Red and White Bordeaux — per Bottle or en Carafe, 5/-; per Glass, 1/-

Passengers on Special Diet are especially invited to make known their requirements to the Chief Tourist Steward

Speciality Foods for Infants are available on request

T

Beer, Lager & Stout, etc.

		Per. Btl.	Nip
Ale and Stout	1/2	—
Ale, Whitbreads	...	1/-	—
Ale, Strong Scotch McEwans		—	1/-
Ale and Beer, American	...	1/6	—
Lager, Grahams		1/2	—
Lager, Tuborg and Carlsberg		1/3	—

		Pint	½ Pint
Lager on Draught	...	1/2	7d.

		Btl.	Spt.
Minerals	9d.	6d.

Cigars

HAVANA
AMERICAN MARKET SELECTION
From 1/3 to 3/6 each

ENGLISH MARKET SELECTION
From 1/6 to 4/- each

AMERICAN DOMESTIC
1/- each

JAMAICAN
1/6 and 2/- each

Tobaccos
Various

Cigarettes

Per Packet from 1/- to 4/-

Playing Cards

Playing Cards per
Pinochle Cards "

G. 39/772 "QUEEN ELIZABETH"

Cocktails and liqueurs
available on the
Queen Mary. (Britton
Collection)

Cocktails
LIQUEURS
Cigars
CIGARETTES

Cunard Line

APERITIFS

	Per Glass
Amer Picon (with Soda Water)	2/-
Vodka	2/-
Aalborg Akvavit	2/-
Gin and Vermouth	2/-
Gin and Bitters ...	1/9
Sherry and Bitters	1/9
Mixed Vermouth	1/6
Vermouth, Italian, Martini Rossi	1/6
Vermouth, French, Noilly Prat	1/6
Vermouth, French, Rozes ...	1/6
Dubonnet	1/6
Kina Lillet	1/6
Fernet Branca ...	1/6

COCKTAILS

	Per Glass
Champagne	6/-
Stinger	4/9
Side Car	4/3
Brandy	4/3
Jack Rose	4/3
Daiquiri	3/9
Bacardi	3/9
Alexander No. 1 ...	3/9
Alexander No. 2 ...	3/6
White Lady	4/3
Manhattan	3/3
Myers	3/-
Old Fashioned ...	3/-
Martini, Very Dry ...	3/-
Martini, Dry	3/-
Bronx	2/9
Dubonnet	2/9
Perfect	2/9
Orange Blossom ...	2/6
Gimlet	2/6

Cunard Line

Liqueurs

	Per Liq Glass
Denis Mounié Cognac, 1865	3/6
Courvoisier Napoleon (80 years old)	3/6
Martell Extra (Guaranteed over 70 years old)	3/6
Gautier Frères Cognac, (70 years old)	3/6
Bisquit Dubouché Cognac, St. Martial	2/6
Hennessy Cognac, X.O.	2/6
Rémy Martin Cognac, V.S.O.P. ...	2/6
Martell Cognac, Cordon Bleu ...	2/6
Hine Cognac, V.V.S.O.P. ...	2/6
Denis Mounié, V.V.S.O.P.	2/6
Chartreuse, Yellow	2/-
Chartreuse, Green	2/-
Bénédictine, D.O.M.	2/-
Drambuie	2/-
Grand Marnier	2/-
Crème de Menthe, Green ...	2/-
Crème de Menthe, White ...	2/-
Cointreau	2/-
Kümmel	2/-
Curaçao, Triple Dry ...	2/-
Cherry Heering	2/-
Crème de Cacao ...	2/-
Peach Brandy	2/-
Apricot Brandy, Apry ...	2/-
Sloe Gin	2/-
Calvados	2/-
Glayva	2/-
Van der Hum	2/-

MIXED DRINKS

	Per Glass
Egg Nogg, Brandy	2/9
Egg Nogg, Whisky	2/9
Egg Nogg, Port	2/3
Egg Nogg, Sherry	2/-
Sherry Flip	2/-
Whisky Flip	2/-
Brandy Flip	2/3
Pimm's No. 1	2/9
Gin Sling	2/6
Clover Club	2/3
Gin Rickey	2/3
Gin Fizz	2/3
Silver Fizz	2/3
Golden Fizz	2/6
Royal Fizz	2/6
Whisky Sour	2/6
Tom Collins	2/6
John Collins	2/6
Rum Collins	2/6
Cuba Libre	2/9
Sherry Cobbler	3/3
Morning Glory	2/3
Planters Punch	2/9

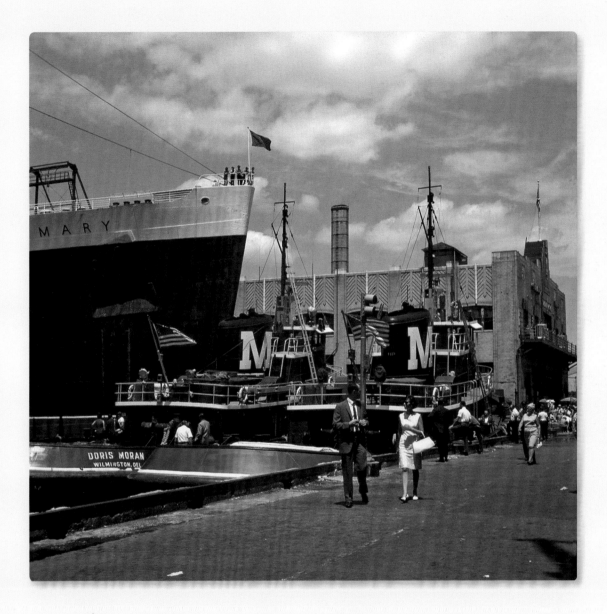

This 1965 view shows the *Queen Mary* docked at Pier 90, West 50th and 52nd Streets, at New York Harbour. Moored just in front of her are two rugged tugs belonging to the well-known New York-based Moran Towing Co. Docking and undocking the gigantic Atlantic Ocean liners like the *Queen Mary* was only a minor portion of their towing activity, but it was the most spectacular operation undertaken by the tugs. (Ernest Arroyo/Britton Collection)

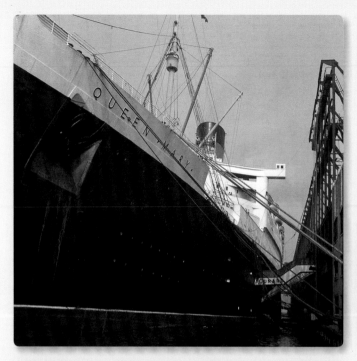

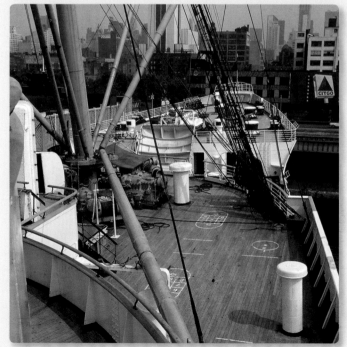

↰ The first impressions of the vastness of the *Queen Mary* came as the taxi arrived at Pier 90 and the sheer magnitude of the black hull could be witnessed, with the red funnels peering above the terminal shed. High above, flags flapped from the masts and the passengers' eyes were quickly drawn towards the gangway proudly labelled 'Cunard', hidden amongst the mooring cables. (Ernest Arroyo/Britton Collection)

↱ Passengers boarding the *Queen Mary* stopped inside the pier and went to their distinctive areas for ticket processing to first, cabin and tourist classes. Visitors usually made a contribution to the local Seaman's Fund in return for a boarding pass. (Ernest Arroyo/Britton Collection)

↲ Once safely on board, after locating the cabin, passengers would explore the vast liner with visitors. A popular stop was to view the sites of New York from the front of the liner. Here they could witness loading into the forward cargo hatch while viewing the New York skyline. (Ernest Arroyo/Britton Collection)

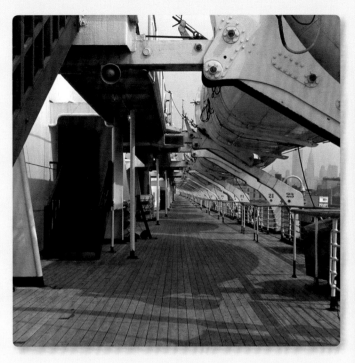

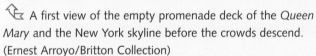 A first view of the empty promenade deck of the *Queen Mary* and the New York skyline before the crowds descend. (Ernest Arroyo/Britton Collection)

A close-up examination of one of the ship's three funnels highlighting her whistles. These whistles sounded a deep and beautiful tone which could be heard for miles across the busy city of New York. The forward funnel was 70ft in height from the boat deck and the diameter of each funnel was 30ft. (Ernest Arroyo/Britton Collection)

It is said that the *Queen Mary* was perhaps the most famous vessel ever launched and she has established her place in the heart of millions. The *Mary* was without doubt a work of art to many with her mass of portholes, rivets and decks. For the record, the *Mary* had 10 million rivets. (Ernest Arroyo/Britton Collection)

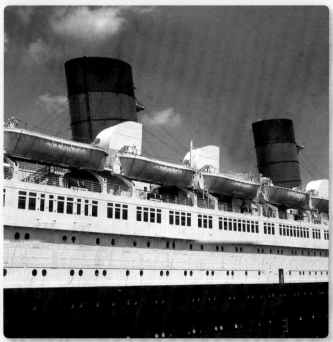

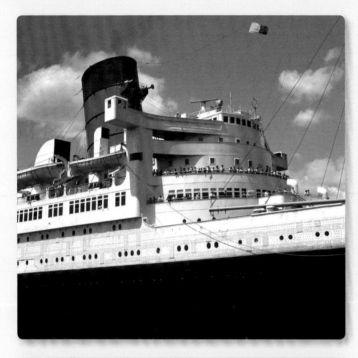

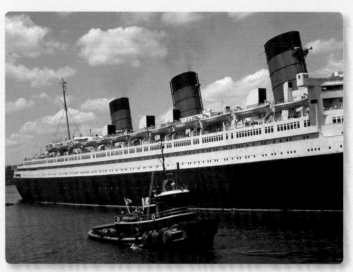

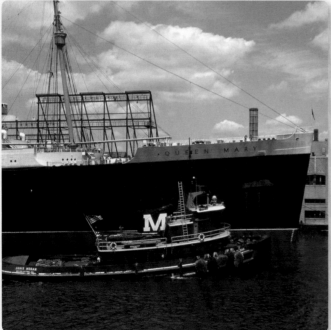

⬑ Hundreds of excited passengers line the decks to peer out in awe and wonder prior to departure from New York. High above on the flying bridge, Captain William 'Bill' Law surveys all and ponders on the routines of departure. (Ernest Arroyo/Britton Collection)

⬑ The Doris Moran tug heads to position, ready to haul the 81,237-ton *Queen Mary* away from Pier 90. A docking pilot would be in full command of the *Queen Mary* at this point. Undocking the Cunard Queen liners was always very challenging. One reason was the conflicting currents in the Hudson. Quite often the top 20ft of the river ran in a different direction to the water below. With the *Queen Mary* drawing 39ft, piloting her became a formidable task which was made to look simple in the hands of an expert. (Ernest Arroyo/Britton Collection)

⬑ Two members of crew peer down from the bow of the *Queen Mary* to observe the Doris Moran tug arriving on station. The Moran Towing & Transportation Co., founded by Michael Moran in 1860, is the oldest and by far the largest towing company in the USA. The diesel electric tugs were all powered by General Motors engines and were notable in being named after members of the Moran family. (Ernest Arroyo/Britton Collection)

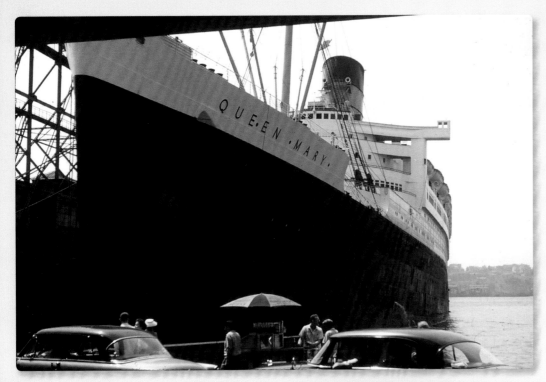

Quayside spectators are served traditional New York bagels and Coca Cola as they absorb the immensity of the *Queen Mary* docked at Pier 92. (Britton Collection)

The crowds gather to witness the departure of the 1,018ft-long *Queen Mary* from Pier 92. (Britton Collection)

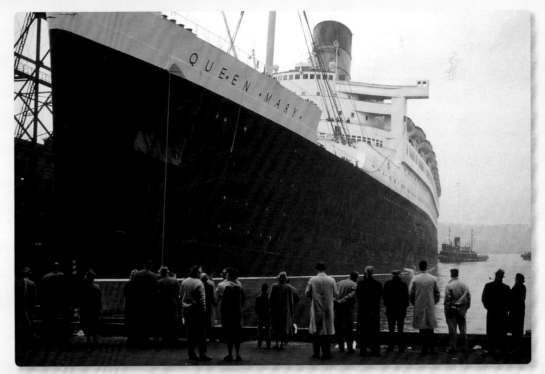

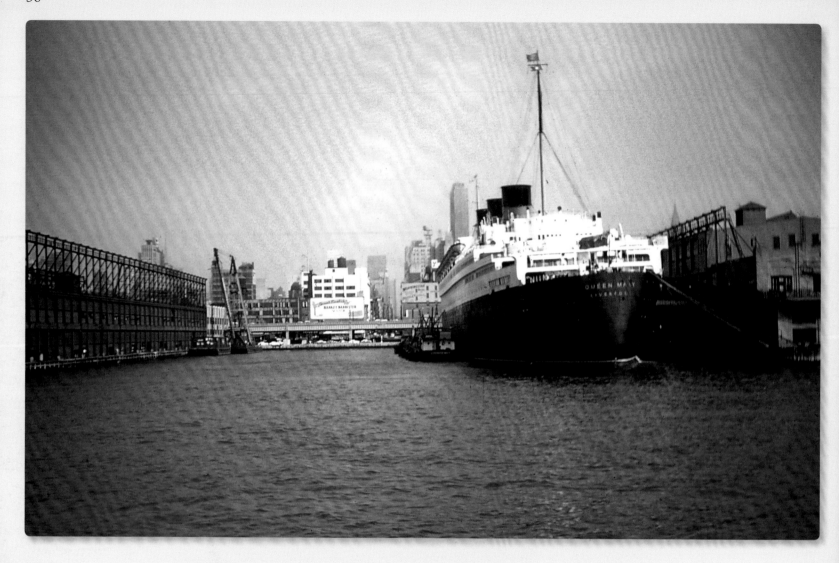

The *Queen Mary* receives fuel from one of the six filling stations which allowed it to be fuelled in just under eight hours. This low-grade fuel oil was known as 'Bunker C' and was ideal for burning efficiently in the *Mary*'s boilers. In the 1950s and '60s, Bunker C was about $24 a ton in New York, but was more expensive in Europe. Cunard would, therefore, ensure that the *Queen Mary* arrived in New York as close as possible to the safe minimum two-day fuel reserve. Right up to forty-five minutes before sailing, all fuel tanks were topped up to the brim to ensure a considerable financial saving. With approximately 1,000 tons of fuel consumed a day, the *Queen Mary* was an expensive vessel to fuel. Once loaded with fuel, 1,500 tons of salt water would be pumped out of the ballast tanks to make certain there was perfect balance. (Britton Collection)

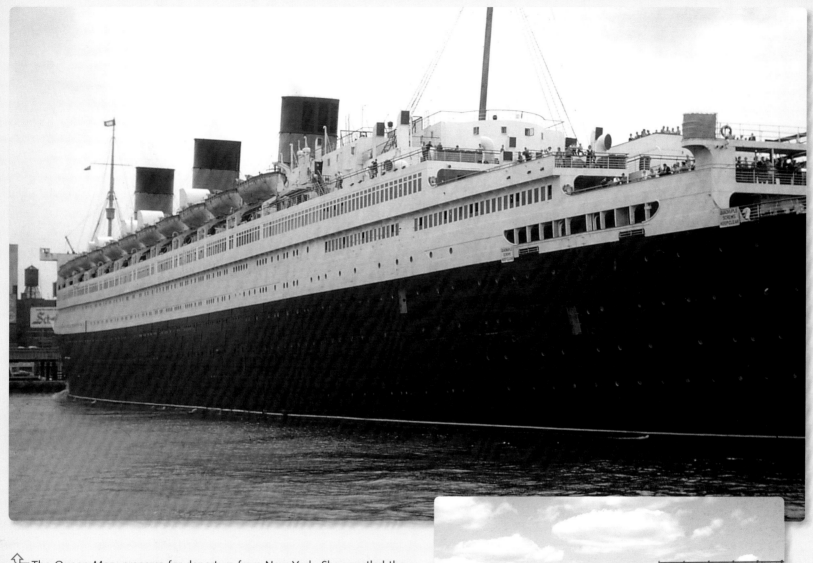

⬑ The *Queen Mary* prepares for departure from New York. She wrestled the famous Blue Riband away from the French Line *Normandie* at an average speed of 31.69 knots and became an instant celebrity in New York. (Britton Collection)

⬑ For the expert, the secret of docking and undocking the *Queen Mary* was to know the proper leverage. When the *Queen Mary* inched upriver away from Pier 90, the docking pilot had to know exactly where to place the assisting Moran tugs to most effectively expedite the operation. Ordinarily, four tugs fastened their lines to the *Mary*'s bow while two other tugs were linked by rope hawsers to her stern. This team of tugs could push or pull at a moment's notice. (Ernest Arroyo/Britton Collection)

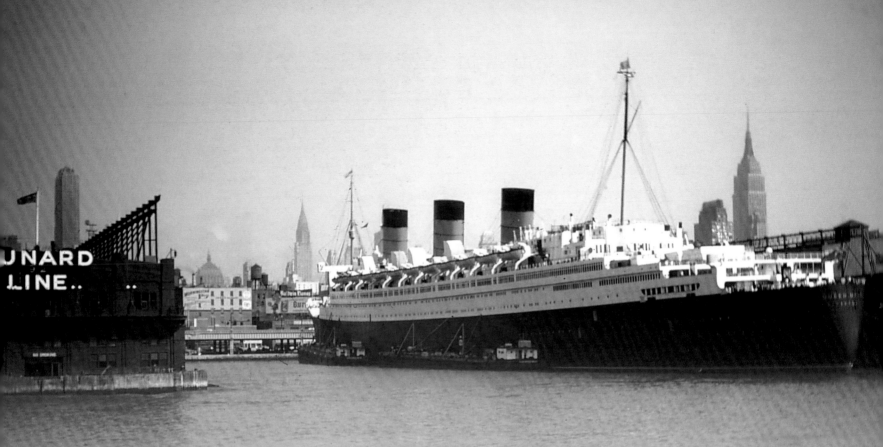

Portrait of a Queen with the Empire State Building in the background. (Britton Collection)

Farewell! (Britton Collection)

The hard work is done. Stand back and watch the *Queen Mary* sail. Exhausted New York dock workers watch from the quay side. (Britton Collection)

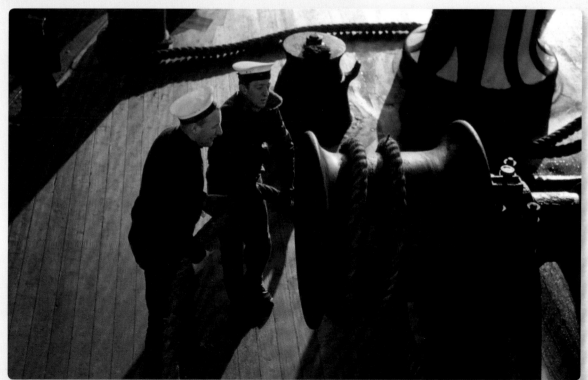

Queen Mary deckhands haul in the giant ropes having let go from Pier 90 at New York. (Britton Collection)

Cheering, waving, singing and sometimes crying. (Britton Collection)

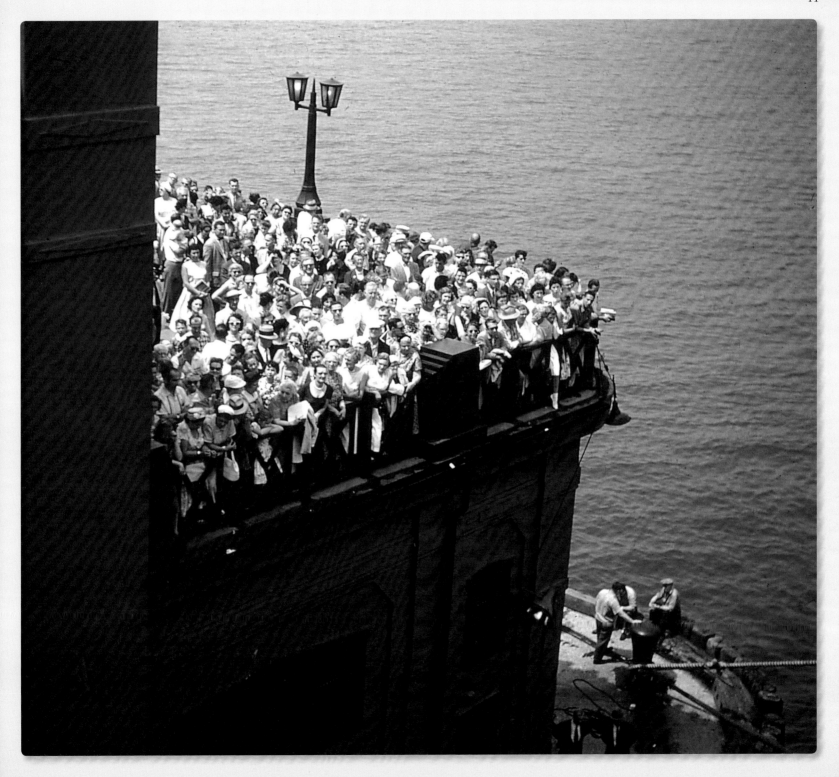

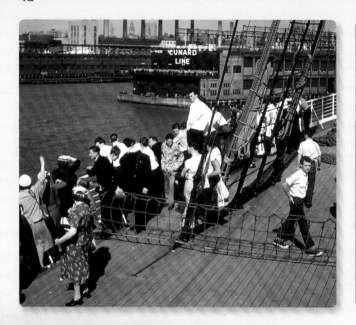

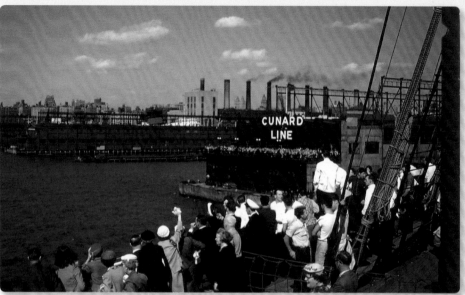

The view from on board the *Queen Mary* as passengers and crew gaze back to the Cunard Pier. (Britton Collection)

Last look at the Cunard pier flanked by the rival French Line pier. (Britton Collection)

Friends and family fill the outer end of the Cunard pier viewing platform for those final moments. The majestic *Queen Mary* slides past, appearing larger and more glamorous than ever. The New York skyline in 1965 was very different from today. The Cunard Piers are visible. On the right of this picture is Pier 88, which had three tenants: the French Line, Greek Line and North German Lloyd. In the late 1950s/early '60s, the adjoining Cunard Piers 90 and 92 were served by the eight Cunard liners. (Britton Collection)

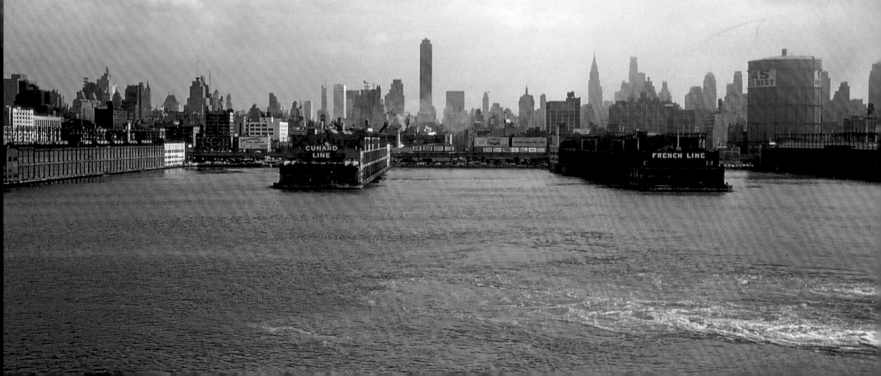

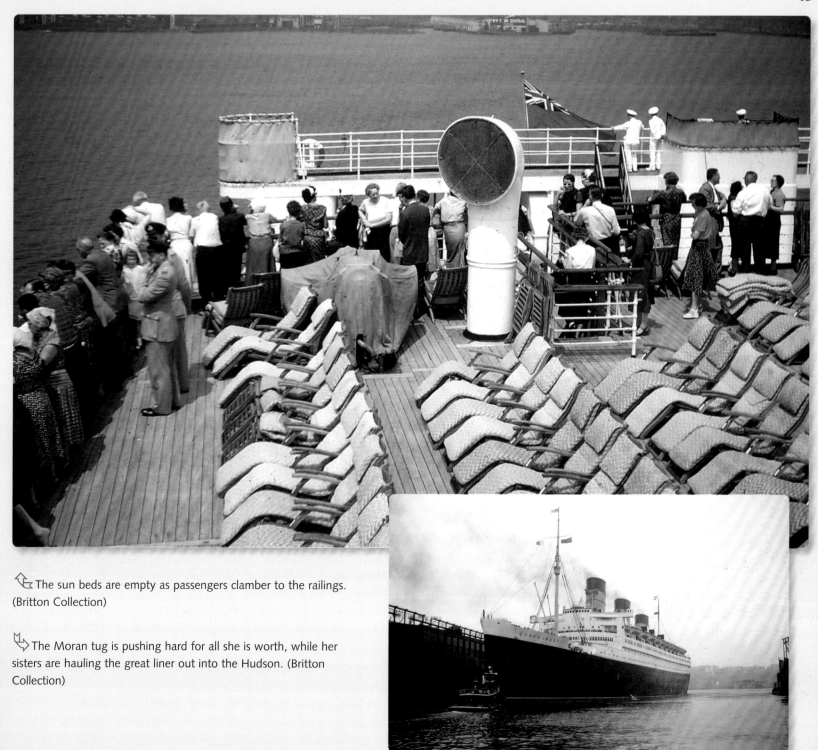

The sun beds are empty as passengers clamber to the railings. (Britton Collection)

The Moran tug is pushing hard for all she is worth, while her sisters are hauling the great liner out into the Hudson. (Britton Collection)

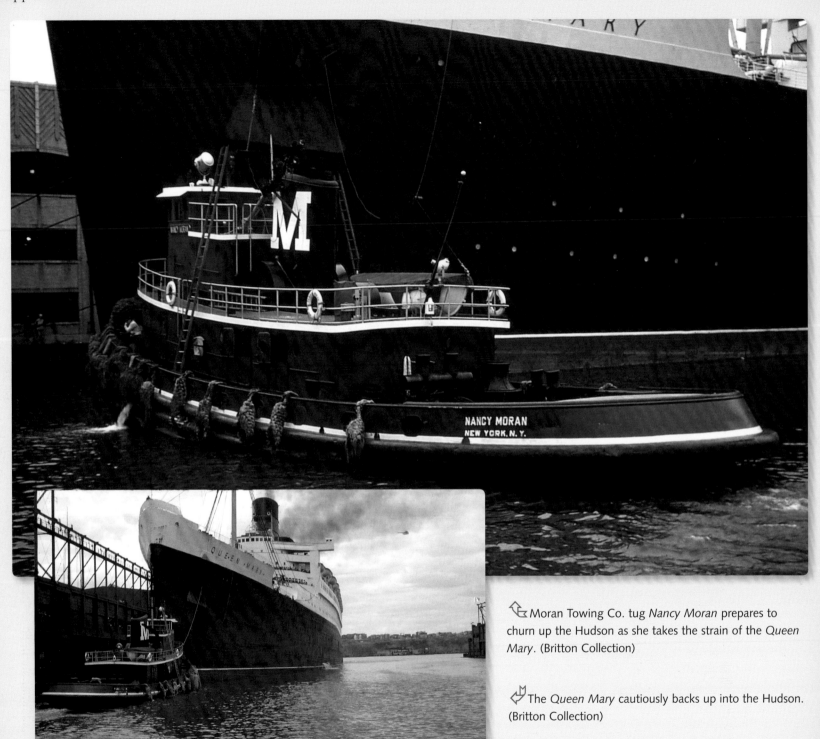

Moran Towing Co. tug *Nancy Moran* prepares to churn up the Hudson as she takes the strain of the *Queen Mary*. (Britton Collection)

The *Queen Mary* cautiously backs up into the Hudson. (Britton Collection)

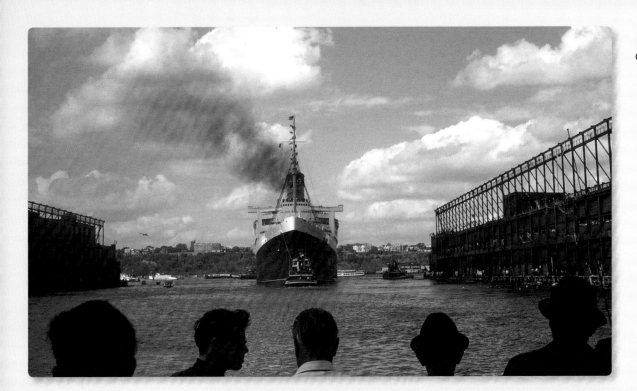

Watchers. (Dave Witmer/Britton Collection)

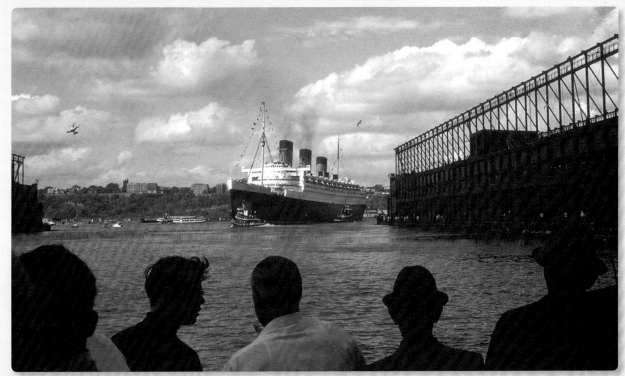

Out into sunlight, watched by New York revellers. (Dave Witmer/Britton Collection)

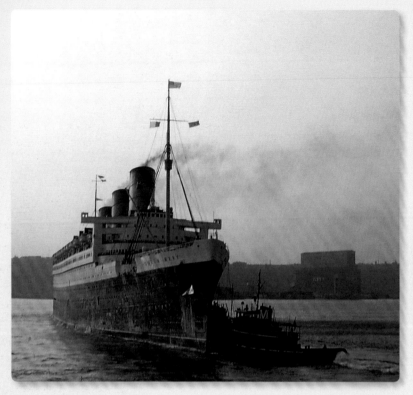

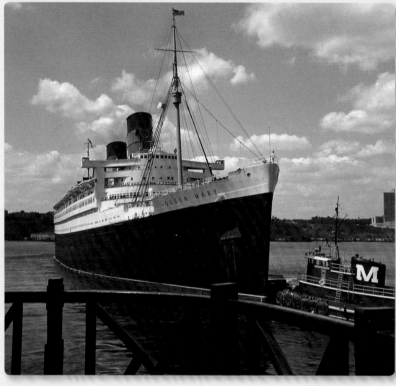

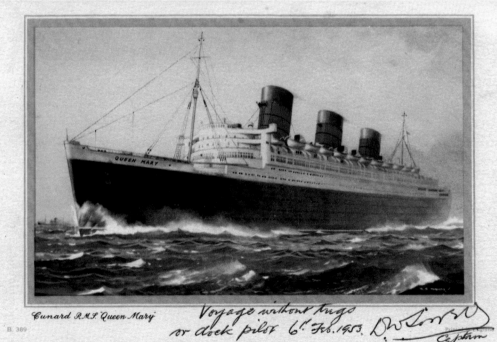

Cunard R.M.S. Queen Mary

Voyage without tugs or dock pilot 6th Feb. 1953. D.W. Sorrell Captain

B 389

The *Queen Mary* is safely out in the Hudson in October 1958, but showing signs of a heavy crossing with her rusting ocean struck paintwork. (Britton Collection)

No one could have predicted the worldwide publicity that surrounded Relieving Captain Donald Sorrell on his first command of the *Queen Mary* in 1953. The docking of the *Queen Mary* at New York without tugs or docking pilot on Friday 6 February 1953 was presented to the world as a feat of seamanship. The departure of the *Mary* in dense fog was an even greater accomplishment. (Ernest Arroyo/Britton Collection)

A commemorative postcard signed by Captain Sorrel himself. (Britton Collection)

Magnificent and majestic, the *Queen Mary* sails slowly down the Hudson. (Ernest Arroyo/Britton Collection)

Job done, the docking pilot returns to Pier 90 for his next turn of duty. (Ernest Arroyo/Britton Collection)

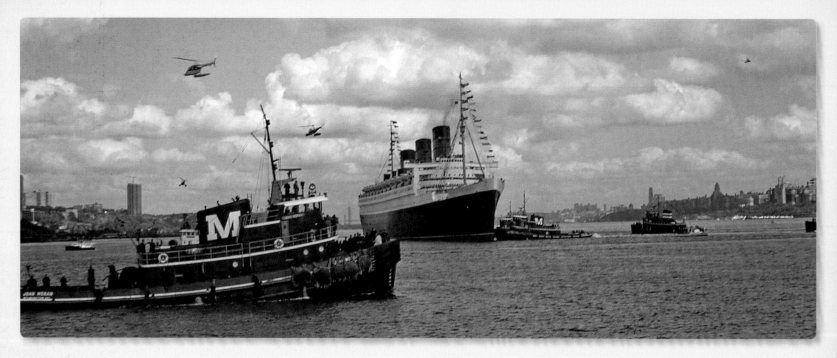

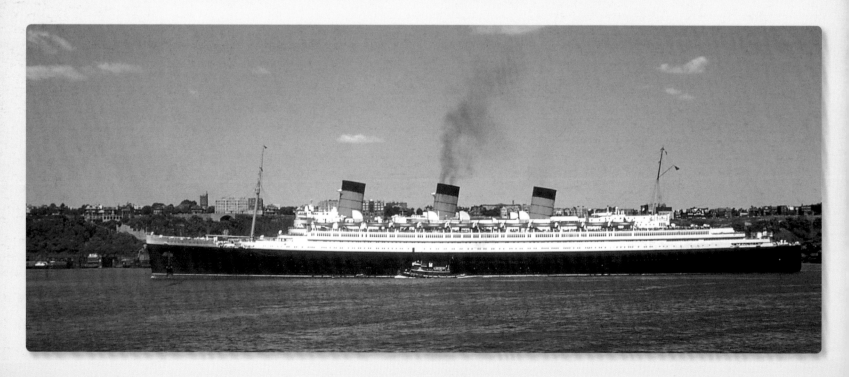

With an escort of helicopters overhead and Moran tugs, the *Queen Mary* bids farewell to New York on 22 September 1967. (Britton Collection)

Flanked by Moran tugs, the outbound *Queen Mary* and pride of the Atlantic heads down the Hudson in 1953. (Arthur Oakman/Britton Collection)

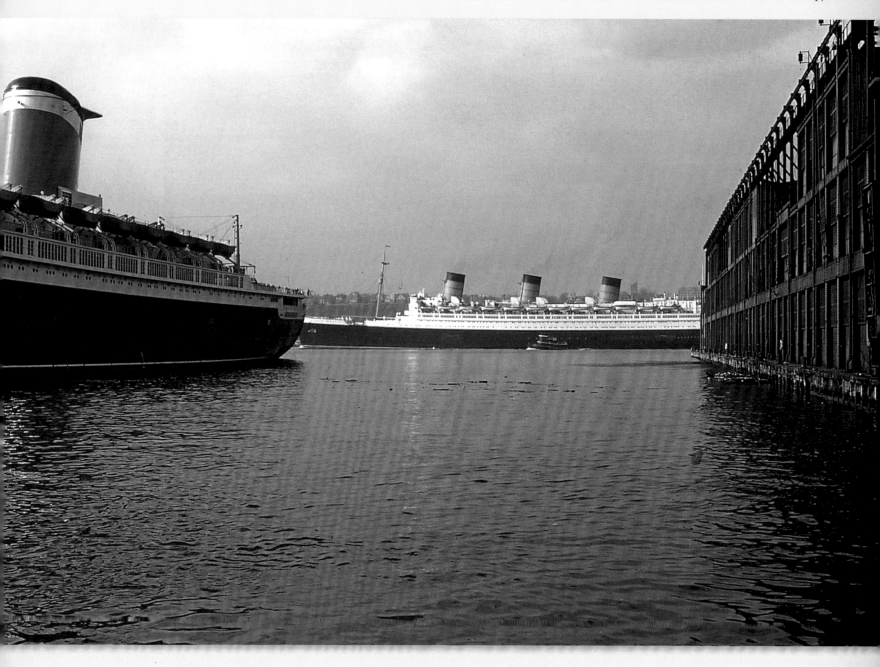

Eastbound *Queen Mary* is beautifully framed between the piers and her record-breaking rival, the United States Line SS *United States*, moored at Pier 86. (Arthur Oakman/Britton Collection)

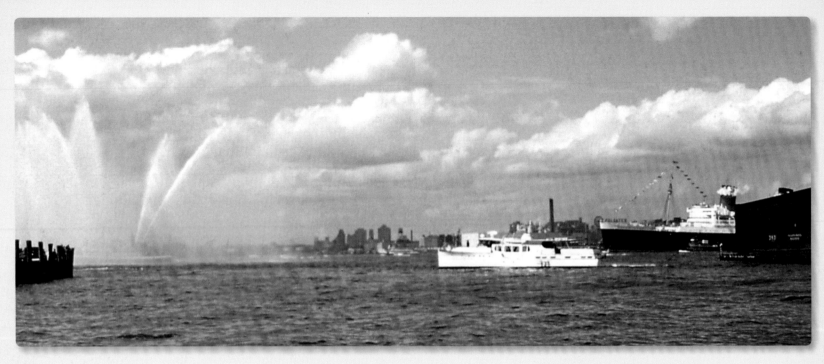

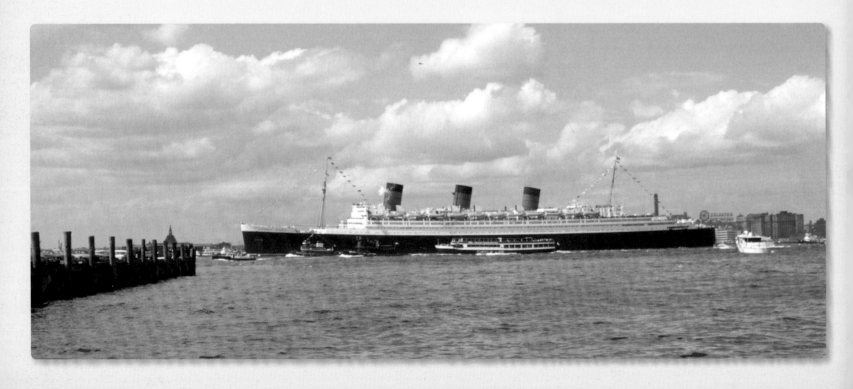

Sad farewell on 22 September 1967 as the *Queen Mary* departs on her final transatlantic voyage. (Britton Collection)

Revellers watch from the rail of the *Queen Mary* in 1947. (Arthur Oakman/Britton Collection)

A spectacular panoramic view of the *Queen Mary* heading away from New York towards the Narrows, Statue of Liberty and Manhattan in 1966. (Britton Collection)

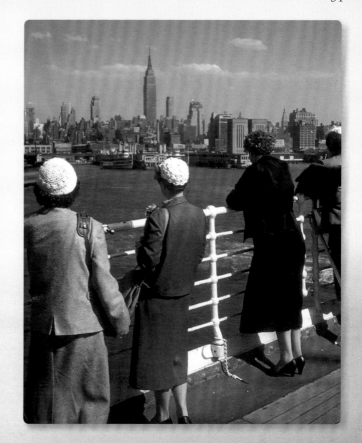

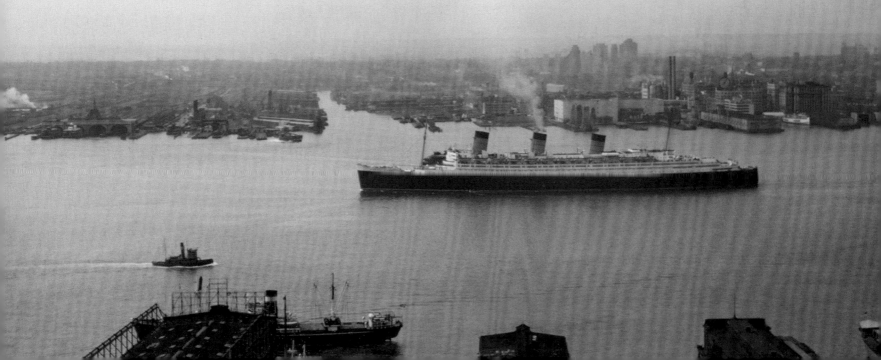

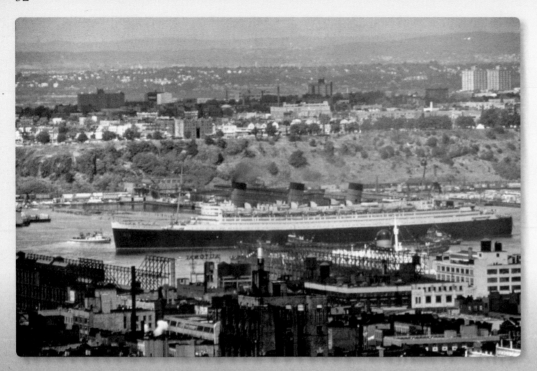

The *Queen Mary* dominates the skyline as she glides down the Hudson in 1965. (Braun Brothers)

This view of the *Queen Mary* departing from New York was saved from the wastepaper bin at Pier 92 and is worthy of preservation! (Cunard)

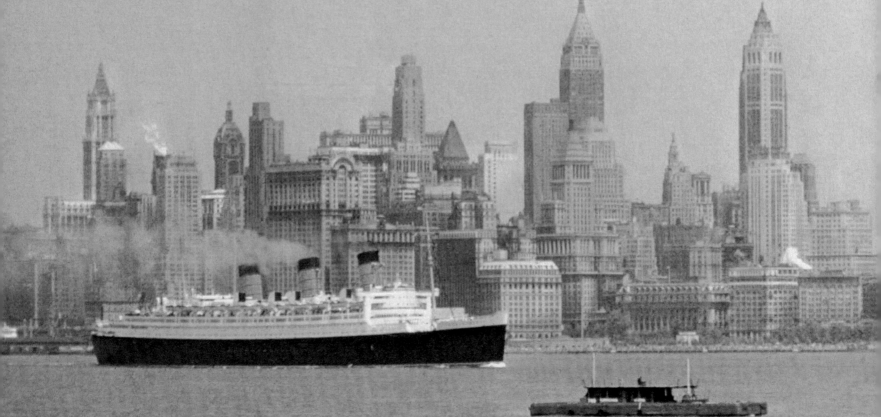

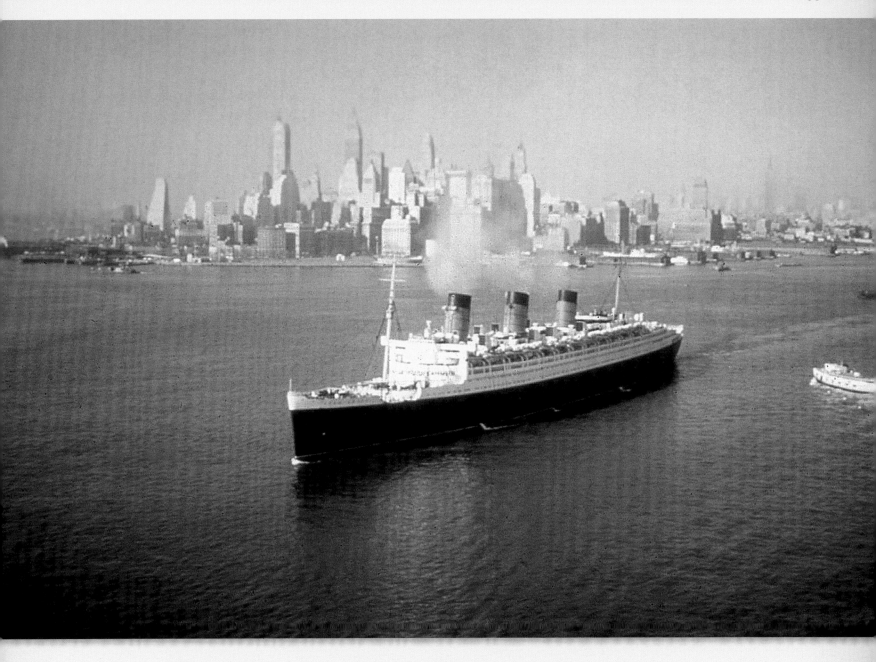

Framed with the background of Manhattan, the *Queen Mary* after a twenty-four-hour stopover in New York. (Braun Brothers)

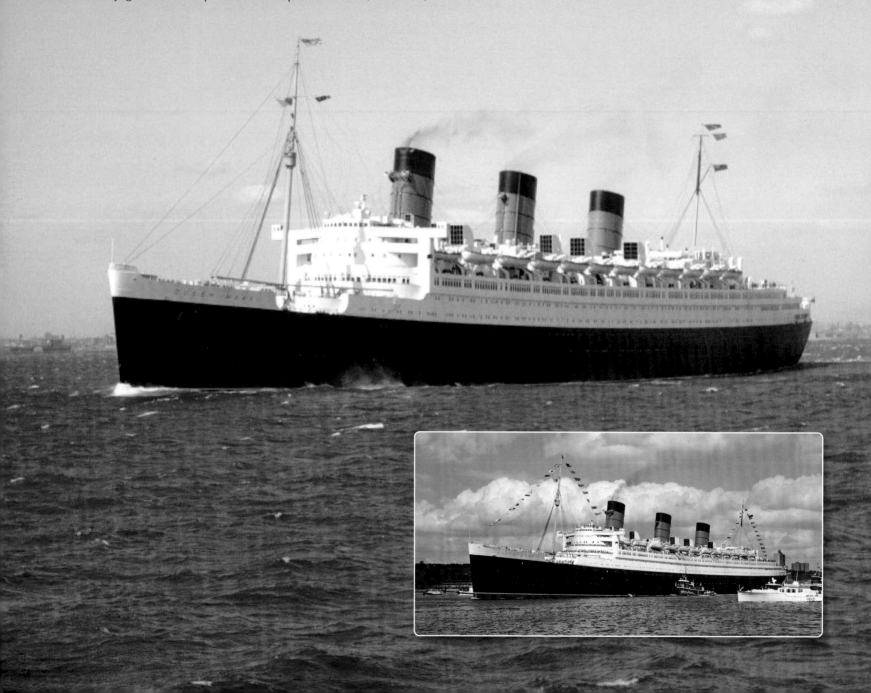

The wind is getting up as the *Mary* heads out of New York in March 1964. Peacetime saw the *Queen Mary* make 1,001 round trips between New York, Cherbourg and Southampton. (Britton Collection)

Bon voyage. The final departure on 22 September 1967. (Marc Piche)

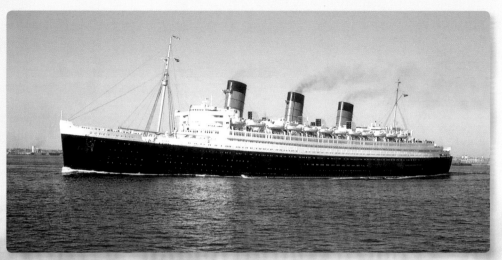

To the Americans, the *Queen Mary* was a floating palace. She never failed to turn heads as she sailed down the Hudson. (Britton Collection)

With her paying-off pennant waving farewell to the escorting Moran tugs, *Queen Mary* heads towards the Narrows and away from New York for the last time on 22 September 1967. (Marc Piche)

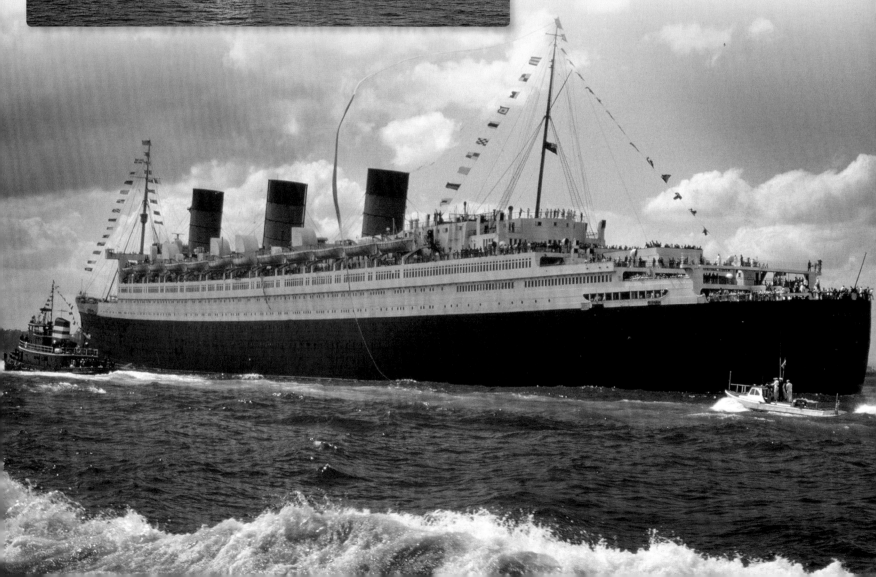

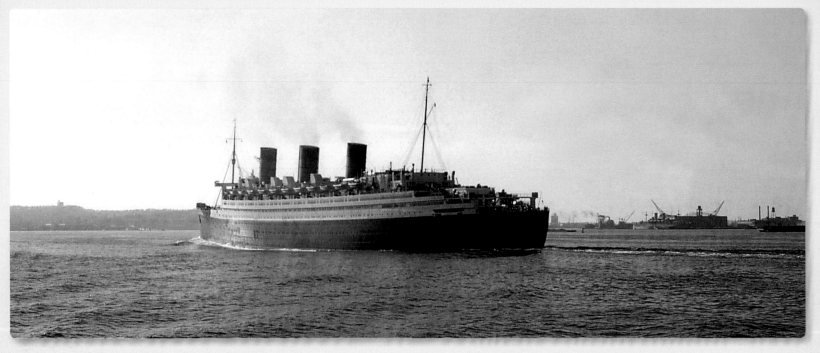

Triumphal progress along the Hudson. (Britton Collection)

Always an impressive image, the *Queen Mary* heads up the Upper New York Bay with Staten Island in the background, 1965. (Britton Collection)

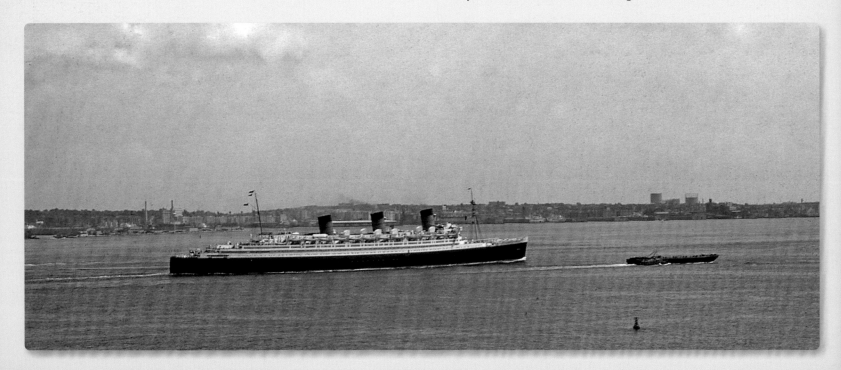

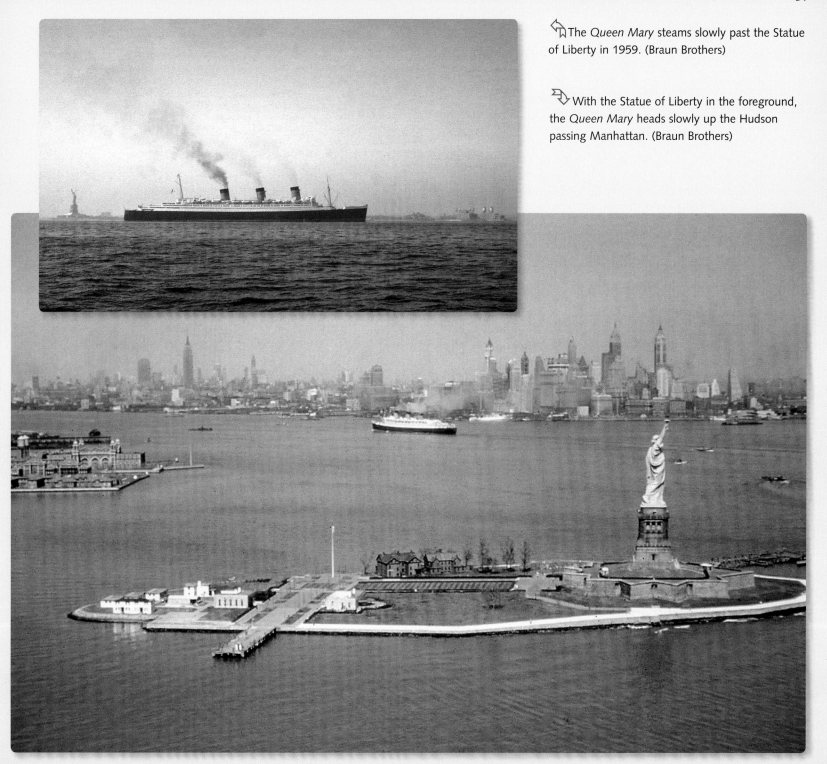

The *Queen Mary* steams slowly past the Statue of Liberty in 1959. (Braun Brothers)

With the Statue of Liberty in the foreground, the *Queen Mary* heads slowly up the Hudson passing Manhattan. (Braun Brothers)

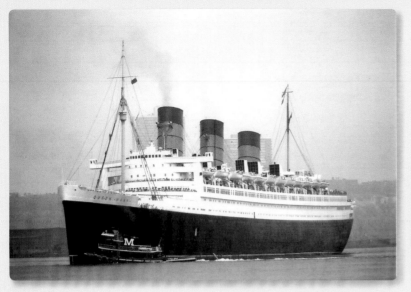

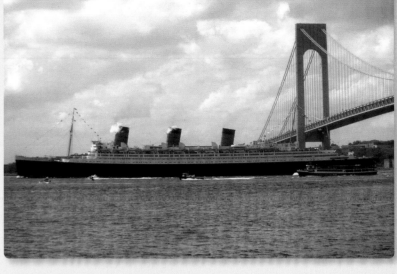

⤢ Assisted by Moran tug *Eugene Moran*, the *Queen Mary* makes a superb sight. From her decks hundreds of passengers gaze from every vantage point. (Braun Brothers/Britton Collection)

⤢ The sound of the sirens from the funnels of the *Queen Mary* echo for the last time as the Cunarder passes underneath the Verrazano-Narrows Bridge on 22 September 1967. (Braun Brothers/Britton Collection)

⤢ A shot of the Verrazano-Narrows Bridge in 1965 taken from the bows of the *Queen Mary*. (Britton Collection)

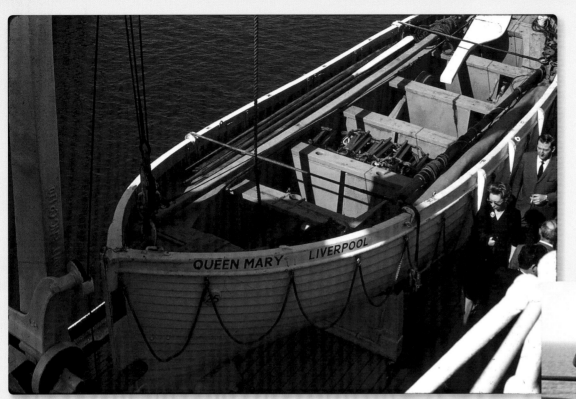

The *Queen Mary* had twenty-four lifeboats powered by 18hp diesel engines, each with a capacity for 145 persons. (Arthur Oakman/Britton Collection)

Shortly after setting sail on the first day of a *Queen Mary* voyage, passengers were acquainted with lifeboat and fire stations. Here we see three members of the Oakman family complete with life jackets in 1953. (Arthur Oakman/Britton Collection)

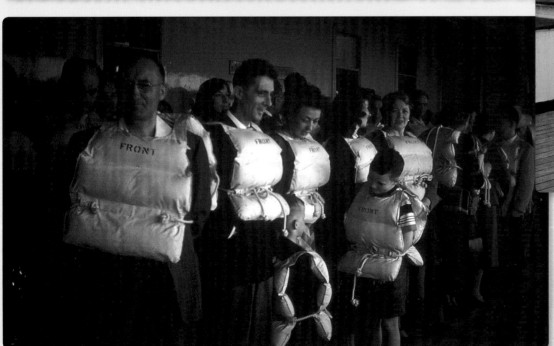

Regulation ritual: lifeboat drill on the *Queen Mary*, 1953. (Arthur Oakman/Britton Collection)

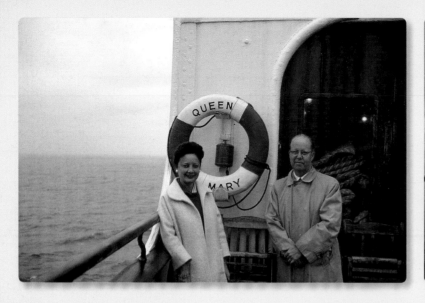

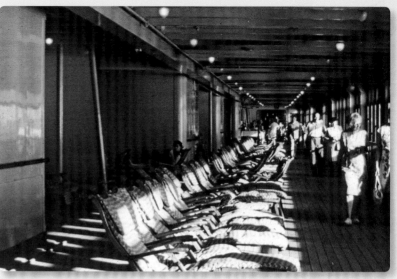

Two American passengers pose in front of a *Queen Mary* life ring. (Britton Collection)

A view along the Promenade Deck of the *Queen Mary* in September 1967. (Commodore G.T. Marr)

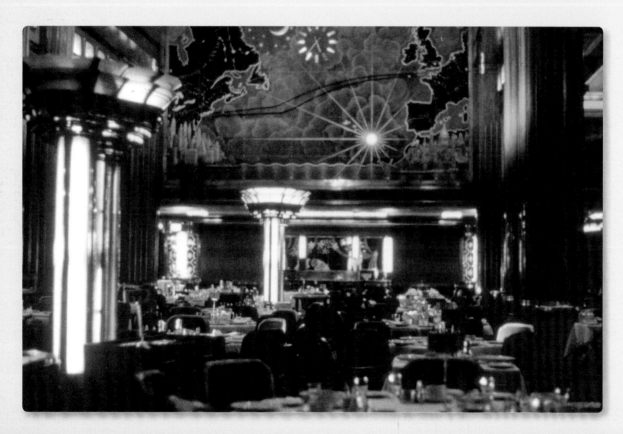

The tables have been prepared for the evening dinner in the main lounge. (Cunard)

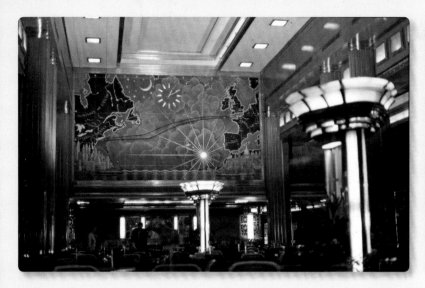

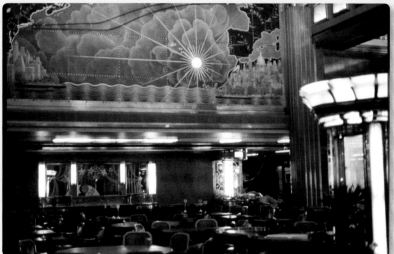

MacDonald Gill, FRIBA, designed a decorative map of the North Atlantic with a silver clock placed high in the centre for the main lounge. Passengers could track the progress of the *Queen Mary* on their voyage by following the position of a crystal model of the ship along the map. (W.J. Windebank/ Barry Eagles Collection)

The main lounge with MacDonald Gill's decorative map above. (W.J. Windebank/Barry Eagles Collection)

The Queen Mother's bedroom marquetry panels in October 1966. The level of comfort offered in the staterooms was of the highest order, with finishing touches like the marquetry panel the norm. (Ernest Arroyo/David Boone Collection)

A tourist-class bedroom with fitted bunk beds, but note the colourful bouquet of flowers. (Ernest Arroyo/David Boone Collection)

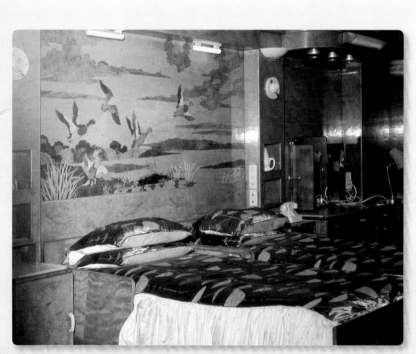

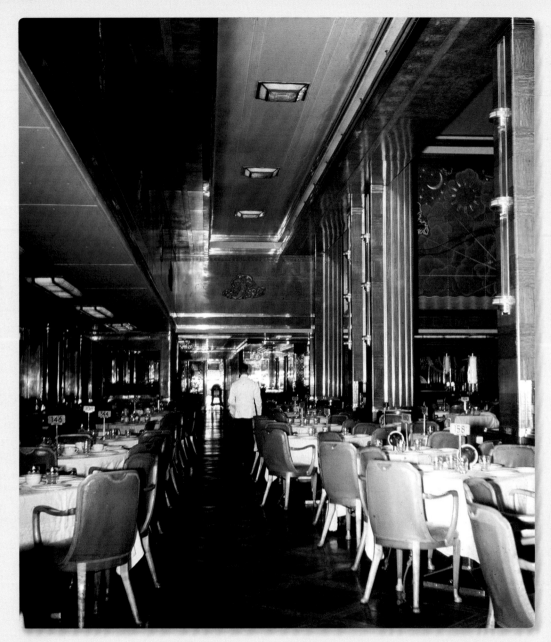

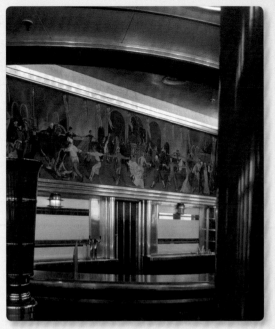

↗ The semicircular observation lounge and cocktail bar. The painting *Royal Jubilee Week 1935* by A.R. Thomson was placed above the Macassar ebony-fronted bar. (Ernest Arroyo/David Boone Collection)

↙ The decorative map of the North Atlantic, designed by MacDonald Gill, can be seen on the right of this picture in the main lounge. (Ernest Arroyo/David Boone Collection)

↘ The observation lounge was a very popular destination for passengers to relax and read a book or discuss pleasantries in comfort. (Ernest Arroyo/David Boone Collection)

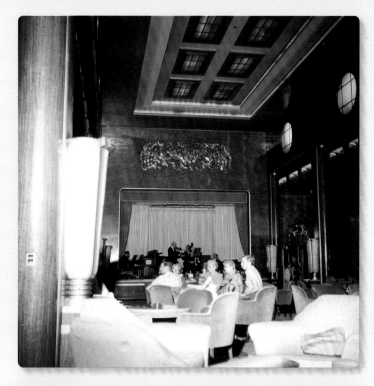

Passengers relax to music in the main lounge. There was a Steinway piano which was finished in Makore veneer and maple burr which complimented the ethos of the main lounge. (Ernest Arroyo/David Boone Collection)

Each evening the vast main lounge was transformed into a ballroom with the furniture removed and the Wilton carpet carefully rolled away. (Ernest Arroyo/David Boone Collection)

In the main lounge there was an enormous carved Gesso panel, *Unicorns in Battle*, by Alfred J. Oakley and Gilbert Bayes. (Ernest Arroyo/David Boone Collection)

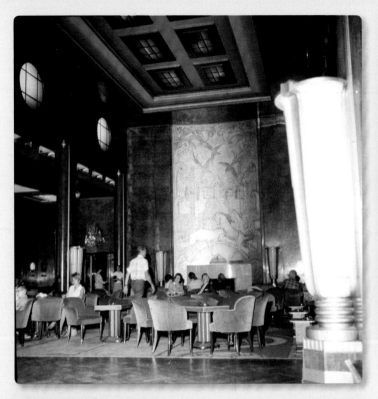

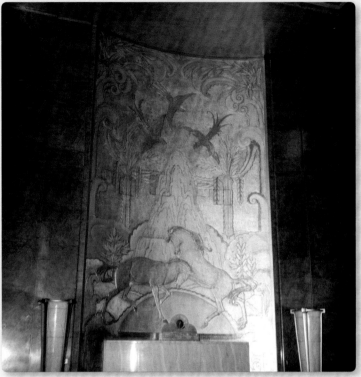

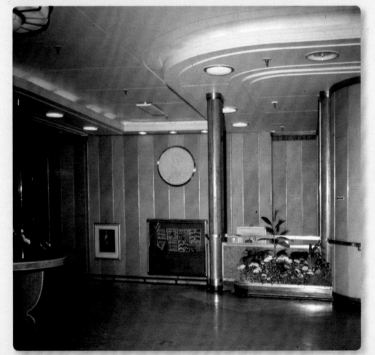

Passengers are seen relaxing in the main lounge. (Ernest Arroyo/ David Boone Collection)

The Gesso panel in the main lounge depicting unicorns in battle. (Ernest Arroyo/David Boone Collection)

The entrance hall on the Promenade Deck. (Ernest Arroyo/David Boone Collection)

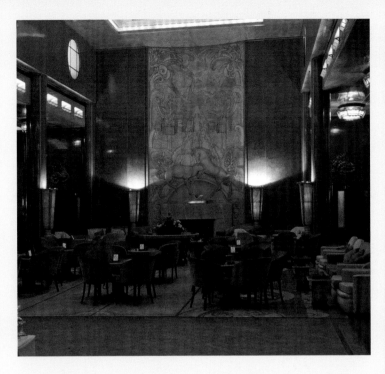

⬑ Up-lights illuminate *Unicorns in Battle* in the main lounge. (Ernest Arroyo/David Boone Collection)

⬏ Right up to the end of the *Queen Mary*'s Cunard service there was a distinctive feeling of pre-war elegance in the main lounge. (Ernest Arroyo/David Boone Collection)

⬎ A steward is pictured hard at work polishing in the main lounge to add that final touch of luxury. (Ernest Arroyo/David Boone Collection)

Pure luxury: the Art Deco period was reflected throughout the ship, with an exquisite wooden-panelled telephone booth complementing display cases, marble columns and a period staircase. (Ernest Arroyo/David Boone Collection)

The opulent main cabin-class dining room contained commissioned artwork by prominent artists. These paintings, murals, carvings and statuettes gave the ship the air of a stately home. (Ernest Arroyo/David Boone Collection)

The entrance hall on the Promenade Deck with the *Queen Mary*'s personal standard and the large medallion depicting Her Majesty's royal personage. (Ernest Arroyo/David Boone Collection)

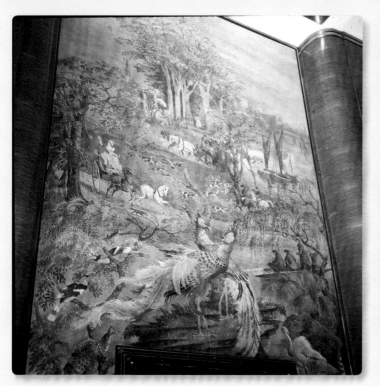

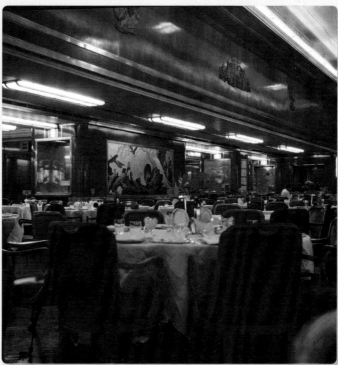

◁ Main dining room tapestry. (Ernest Arroyo/David Boone Collection)

▷ A view across the main dining room. The colour scheme comprised the browns of autumn with three shades of Brazilian Peroba panels. (Ernest Arroyo/David Boone Collection)

▽ In a 'floating town', shops were a fundamental on-board facility. As would be expected, the cabin-class shopping centre was the largest and most elaborate. Here we see the Bond Street shop. (Ernest Arroyo/David Boone Collection)

The set of bronze doors designed by Walter and Donald Gilbert in the main dining room had for their theme the figures of Castor and Pollux, who were the guardians of sailors. (Ernest Arroyo/David Boone Collection)

Bond Street shops. (Ernest Arroyo/David Boone Collection)

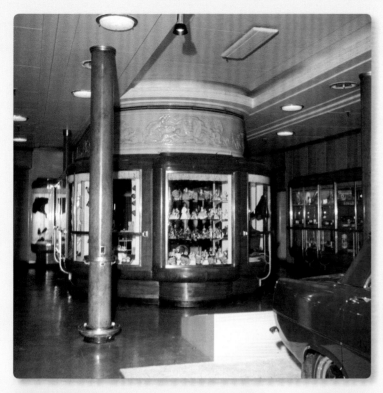

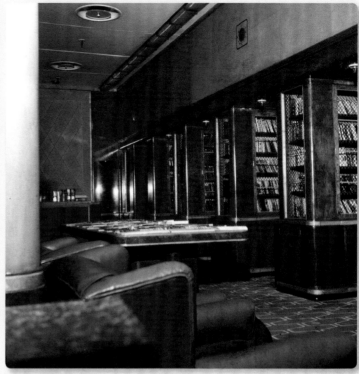

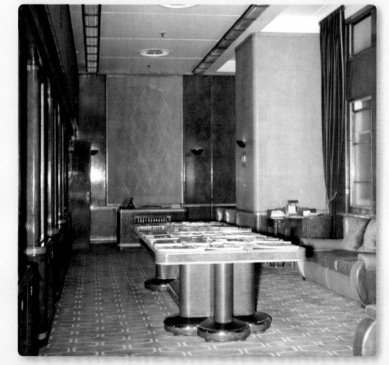

The shopping area, Piccadilly Circus. (Ernest Arroyo/David Boone Collection)

The restful cabin-class library showing the quality of craftsmanship of the cabinets and panelling. It had soft, velvet curtains and deep-pile carpets of grey, brown and slate blue. (Ernest Arroyo/David Boone Collection)

A fine display of recently published books are presented on the table in the cabin-class library. (Ernest Arroyo/David Boone Collection)

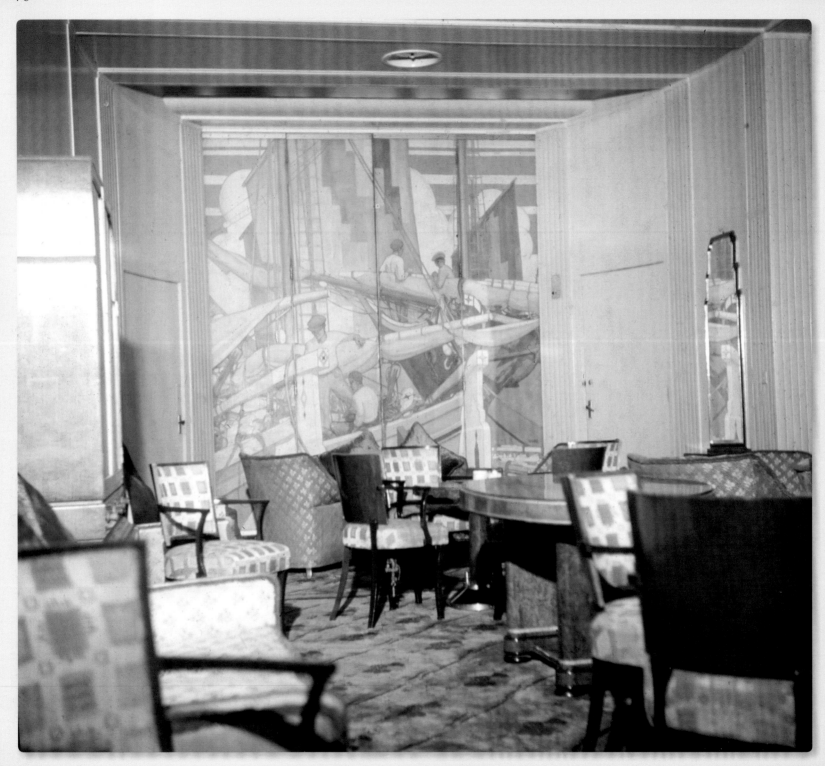

While the passengers were up on deck stewards set to work hoovering and polishing to maintain a scene like this. (Ernest Arroyo/David Boone Collection)

The cabin-class long gallery. (Ernest Arroyo/David Boone Collection)

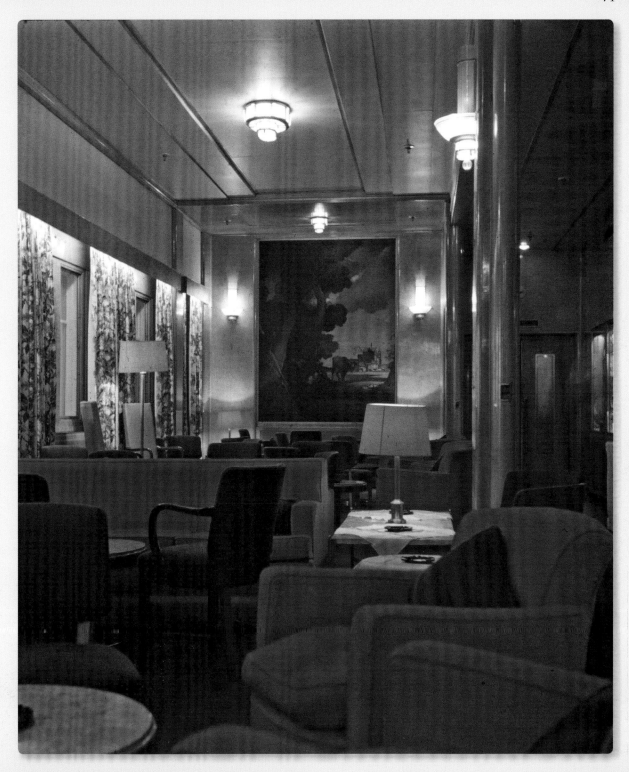

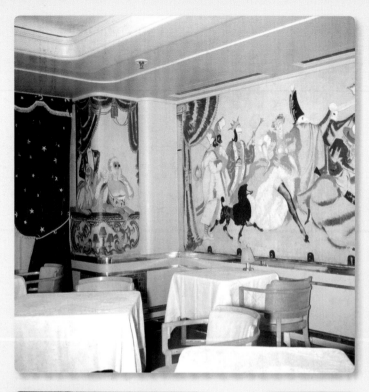

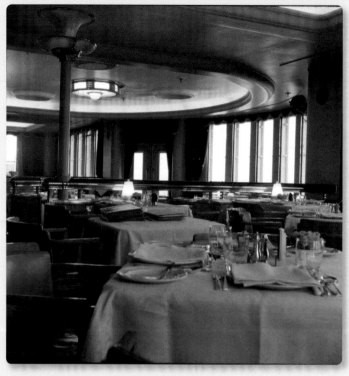

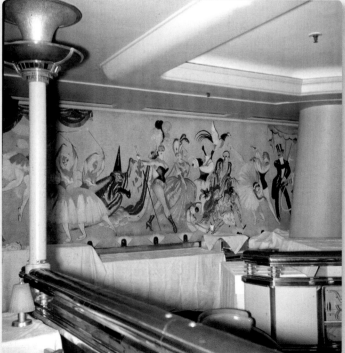

The exclusive Verandah Grill was located at the aft end of the sun deck. It was used for dancing and the serving of à la carte meals. Additionally, it provided a cocktail bar and supper service. The Verandah Grill became the place to be seen and was very popular with film stars and celebrities. (Ernest Arroyo/David Boone Collection)

Exciting artwork covering the walls of the Verandah Grill reflected the different forms of entertainment within the performing arts. (Ernest Arroyo/David Boone Collection)

The Verandah Grill. (Ernest Arroyo/David Boone Collection)

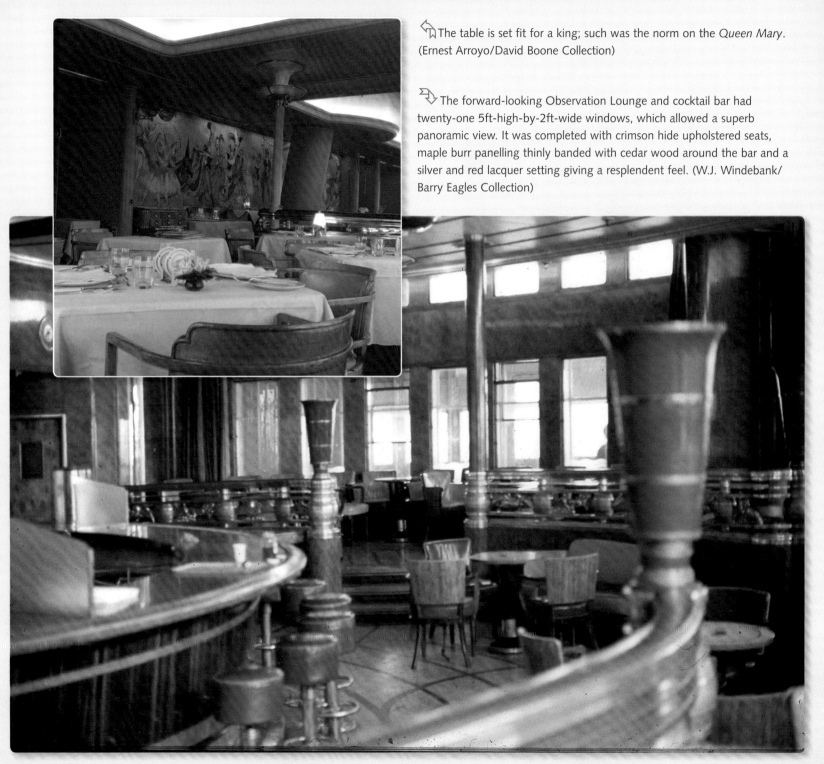

⬑The table is set fit for a king; such was the norm on the *Queen Mary*. (Ernest Arroyo/David Boone Collection)

⬎The forward-looking Observation Lounge and cocktail bar had twenty-one 5ft-high-by-2ft-wide windows, which allowed a superb panoramic view. It was completed with crimson hide upholstered seats, maple burr panelling thinly banded with cedar wood around the bar and a silver and red lacquer setting giving a resplendent feel. (W.J. Windebank/Barry Eagles Collection)

A proud moment at the Gala Dinner on the *Queen Mary*. (Britton Collection)

Captain John Treasure Jones tops up his glass on the final voyage. Captain Jones was one of the kindest and gentlest members of the Cunard staff who had the patience of Job, especially when answering dozens of questions from the young Andrew Britton! (Commodore G.T. Marr)

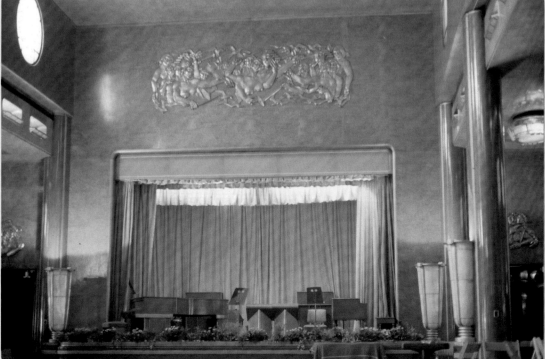

The stage of the first-class main lounge on the *Queen Mary* was a second home to the Britton family. Here, Alfred John Britton was at one time leader of the orchestra and his eldest son Norman Alfred Britton was leading violinist. (W.J. Windebank/Barry Eagles Collection)

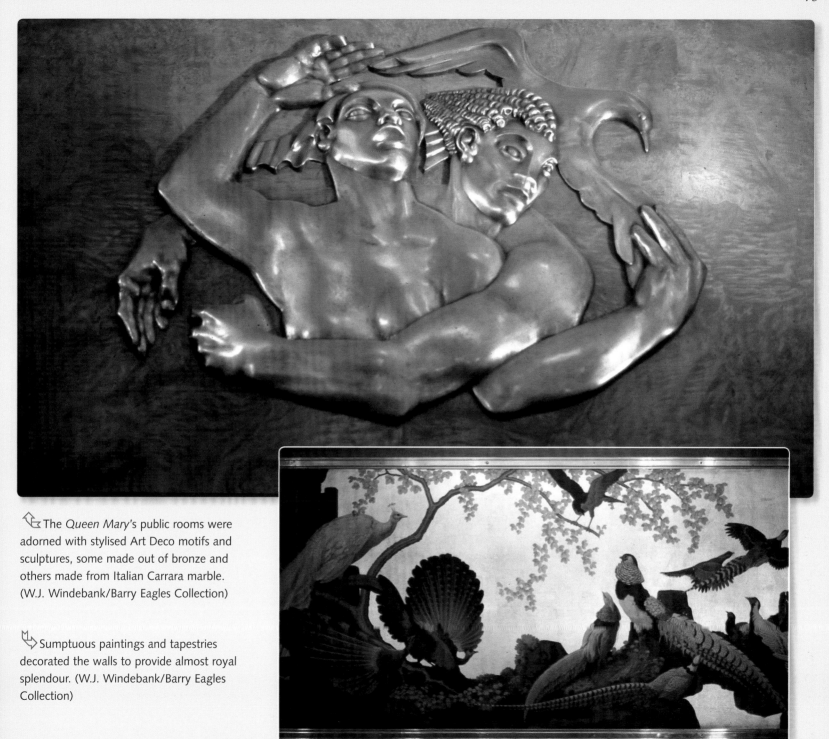

The *Queen Mary*'s public rooms were adorned with stylised Art Deco motifs and sculptures, some made out of bronze and others made from Italian Carrara marble. (W.J. Windebank/Barry Eagles Collection)

Sumptuous paintings and tapestries decorated the walls to provide almost royal splendour. (W.J. Windebank/Barry Eagles Collection)

Shipbuilder John Brown & Company's construction plate. (Cunard)

The *Queen Mary*'s first-class swimming pool, June 1964, has been drained of water. When open to passengers, it was a very hot, sticky and noisy place. In rough seas the pool could be quite dangerous. (W.J. Windebank/ Barry Eagles Collection)

The bridge of the *Queen Mary*: every movement was commanded from here, a place where the ship's brass steering wheel, telegraphs, voice pipes and binnacles were constantly polished to 'mirror finish perfection'. The bridge was panelled with a rich, varnished, deep English oak. At times when the ship was on the move it could be bustling with activity, but in the depths of the night it could be as quiet as a church at prayer. The bridge of the *Queen Mary* had a unique smell of Brasso and polish, which is a lasting memory to all those who worked on it or were honoured enough to visit. (W.J. Windebank/Barry Eagles Collection)

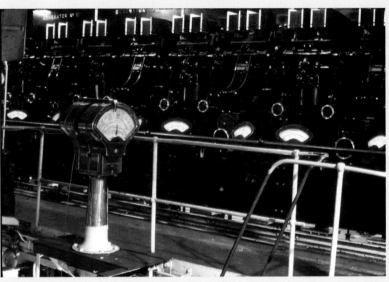

Shipbuilder John Brown & Co.'s engine plate. (W.J. Windebank/Barry Eagles Collection)

The generator control room. Electricity on the *Mary* was provided by two separate power stations, producing a total of 9,100 kilowatts – sufficient power for a city! (Cunard)

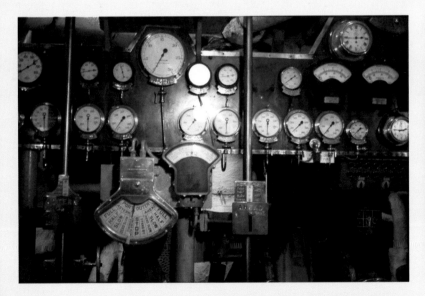

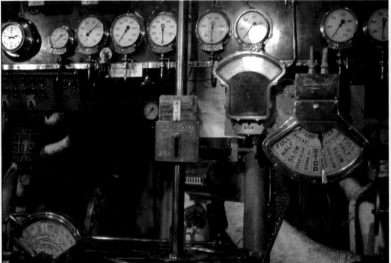

Deep inside the dark depths of the *Queen Mary*'s hull was the engine room control panel. It was a hot, sweaty and noisy place which was at the heart of the ship's power. (W.J. Windebank/Barry Eagles Collection)

The complex mass of gauges on the engine room control panel were closely monitored to ensure there was sufficient steam, oil feed and rpm to drive the gigantic propellers. (W.J. Windebank/Barry Eagles Collection)

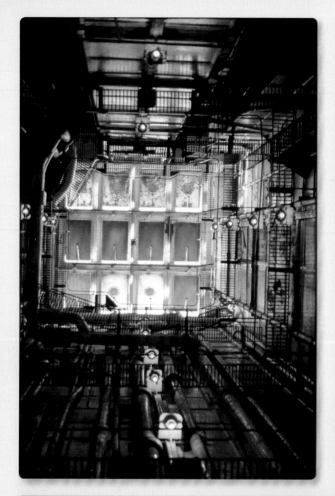

A mass of lights, ladders, pipes and ventilators that were unseen by passengers but crucial to the engines of the *Queen Mary*. (W.J. Windebank/ Barry Eagles Collection)

Spectacular mid-Atlantic sunrise seen from a porthole of the *Queen Mary*. (Britton Collection)

Atlantic sunset on the *Queen Mary*. (Britton Collection)

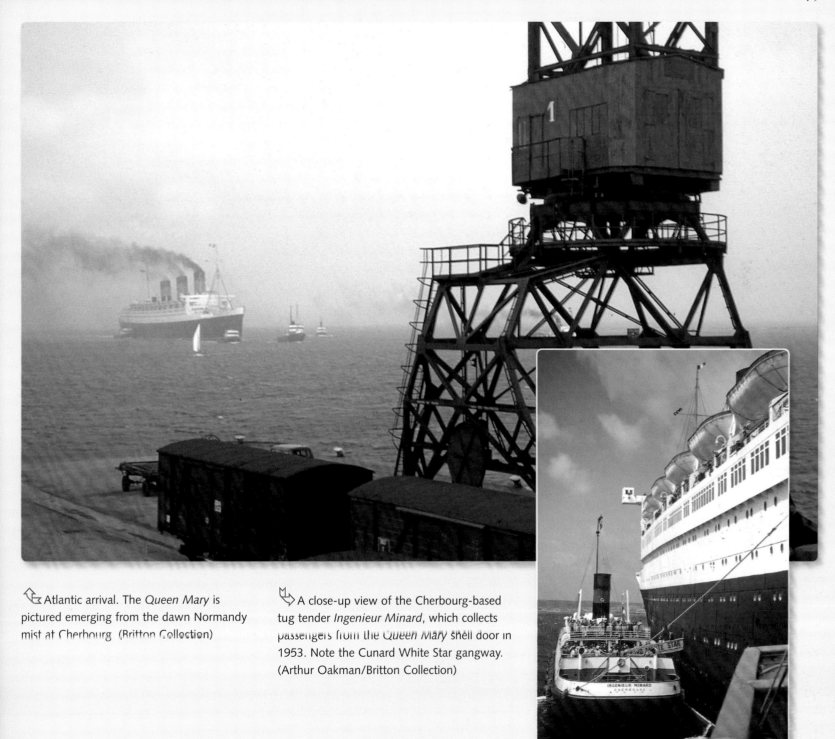

Atlantic arrival. The *Queen Mary* is pictured emerging from the dawn Normandy mist at Cherbourg. (Britton Collection)

A close-up view of the Cherbourg-based tug tender *Ingenieur Minard*, which collects passengers from the *Queen Mary* shell door in 1953. Note the Cunard White Star gangway. (Arthur Oakman/Britton Collection)

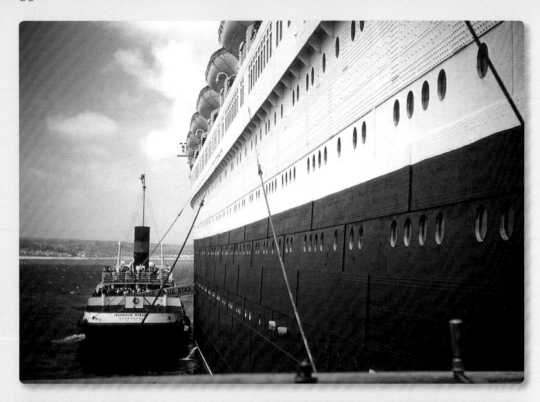

When the tide and winds were right, the *Queen Mary* would anchor in the man-made Cherbourg Harbour to drop off passengers via tug tender, saving time and money. This was the scene of the famous grounding of the *Queen Mary* while under the captaincy of Harry Grattidge in January 1948. The grounding aft of the *Queen Mary* was the result of the wind veering to the SSW. (Arthur Oakman/ Britton Collection)

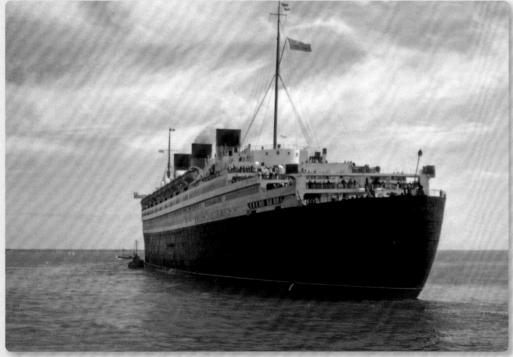

The *Queen Mary* is ready to set sail again from Cherbourg in 1953. Next stop: New York. (Arthur Oakman/Britton Collection)

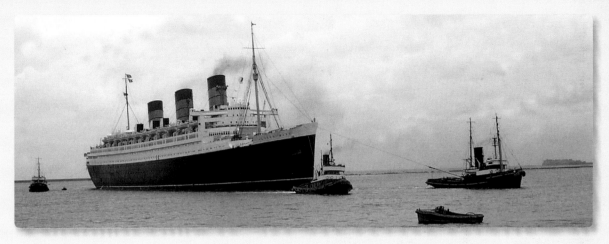

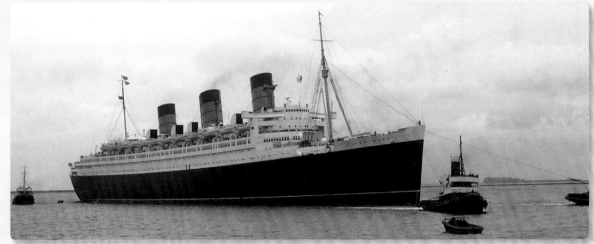

The *Queen Mary* enters Cherbourg on 20 June 1967 escorted by a flotilla of French tugs. (A.E. Bennett)

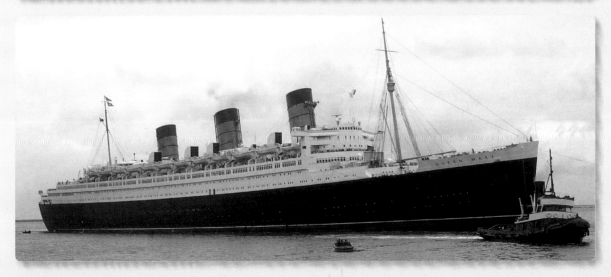

Looking down across the *Queen Mary*'s lifeboats as she enters Cherbourg we can see the escorting French Pilot boat/tug which has transferred to assist with docking at the port. (Britton Collection)

The French tug tender *Ingenieur Reibell* heads away from the *Queen Mary* with first-class passengers for the boat train to Paris. (Britton Collection)

The crew of the *Queen Mary* looks out over the forecastle in readiness for the departure from Cherbourg to Southampton on 20 June 1967. (A.E. Bennett)

The French tug tender *Ingenieur Reibell* prepares to attach a line in preparation for hauling the *Queen Mary* from Cherbourg quayside, 20 June 1967. (A.E. Bennett)

Looking forward down the almost deserted Promenade Deck across Cherbourg Harbour, 20 June 1967. (A.E. Bennett)

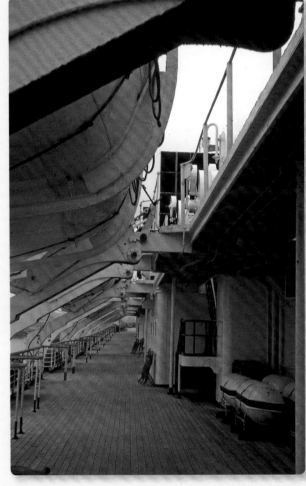

Not a passenger in sight in this view of the lifeboat deck of the *Queen Mary* at Cherbourg in 1966. (Britton Collection)

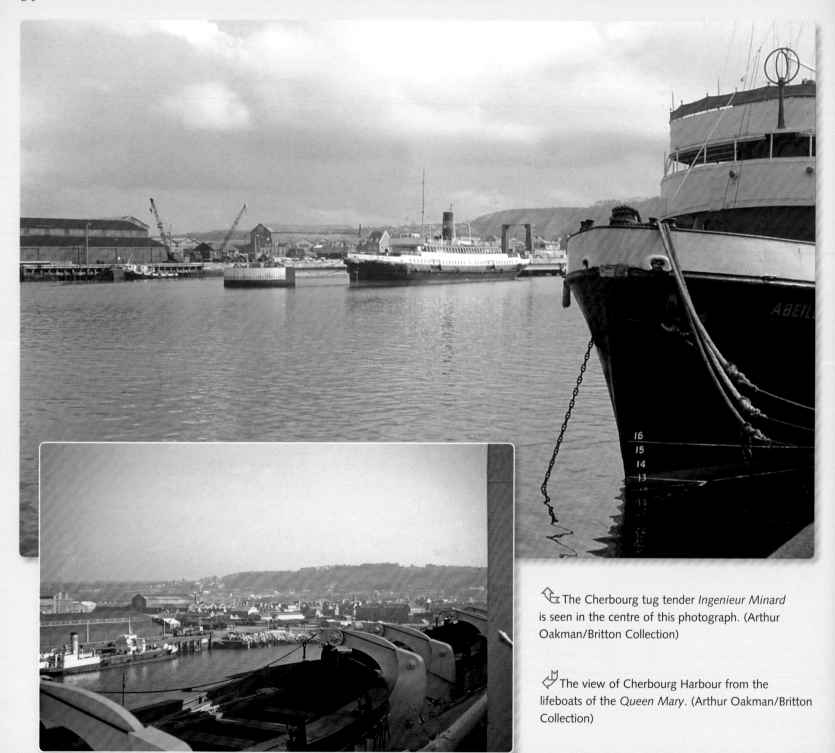

↖ The Cherbourg tug tender *Ingenieur Minard* is seen in the centre of this photograph. (Arthur Oakman/Britton Collection)

↙ The view of Cherbourg Harbour from the lifeboats of the *Queen Mary*. (Arthur Oakman/Britton Collection)

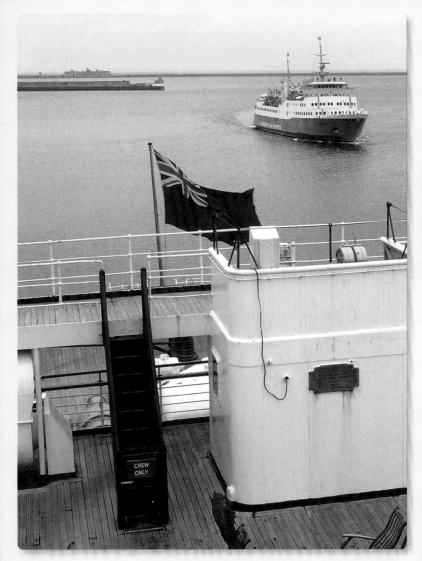

Viewed from the decks of the *Queen Mary*, a Townsend Thornsen car ferry arrives at Cherbourg. (A.E. Bennett)

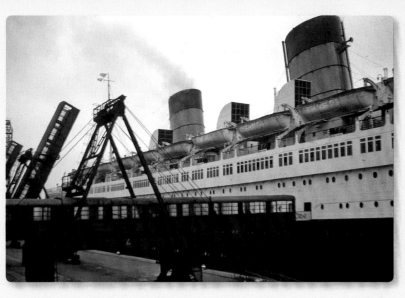

The telescopic gangways swing into action following the arrival of the *Queen Mary* at Cherbourg. (Britton Collection)

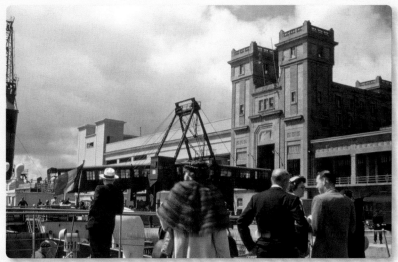

The Cherbourg tug tender *Ingenieur Minard* with passengers from the *Queen Mary* approaches the quayside in 1953. The impressive port building is almost like a cathedral in appearance. Many of the passengers are bound for Paris on a train hauled by one of the Chapelon E Class pacific steam locomotives. (Arthur Oakman/Britton Collection)

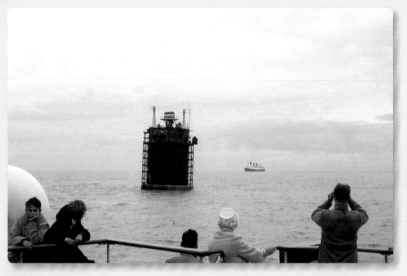

Eager spectators watch in anticipation as the *Queen Mary* approaches the Nab Tower of Bembridge on the Isle of Wight, 27 September 1967. However, the boy on the left of the picture appears to be unimpressed! (A.E. Bennett)

The outward-bound Royal Mail Line RMS *Andes* has just dropped off her pilot at the Nab Tower on 27 September 1967. (A.E. Bennett)

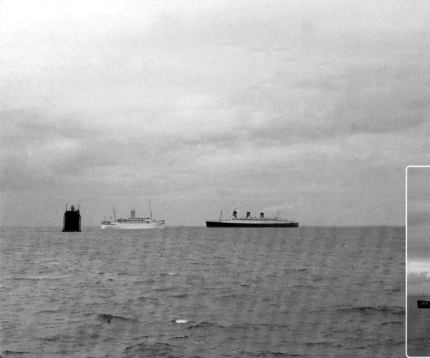

Royal Mail Line RMS *Andes*, having dropped off her pilot at the Nab Tower near Bembridge on the Isle of Wight, cautiously passes the inbound Cunard RMS *Queen Mary*. (A.E. Bennett)

The inbound *Queen Mary* slows to collect the pilot from the Trinity House boat *Patricia* off the Nab Tower at Bembridge, Isle of Wight, 27 September 1967. (A.E. Bennett)

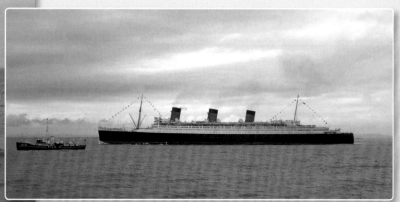

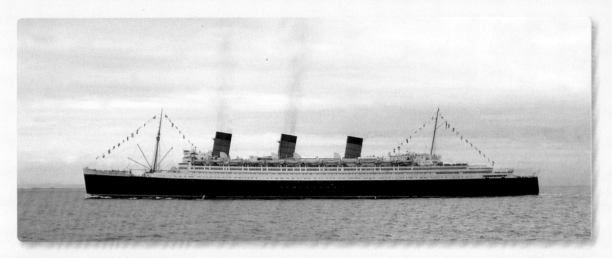

The inbound *Queen Mary* arrives off Ryde on the Isle of Wight on 27 September 1967. (A.E. Bennett)

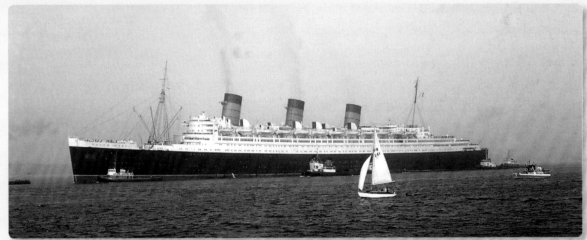

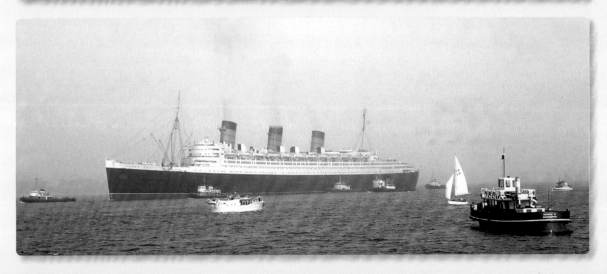

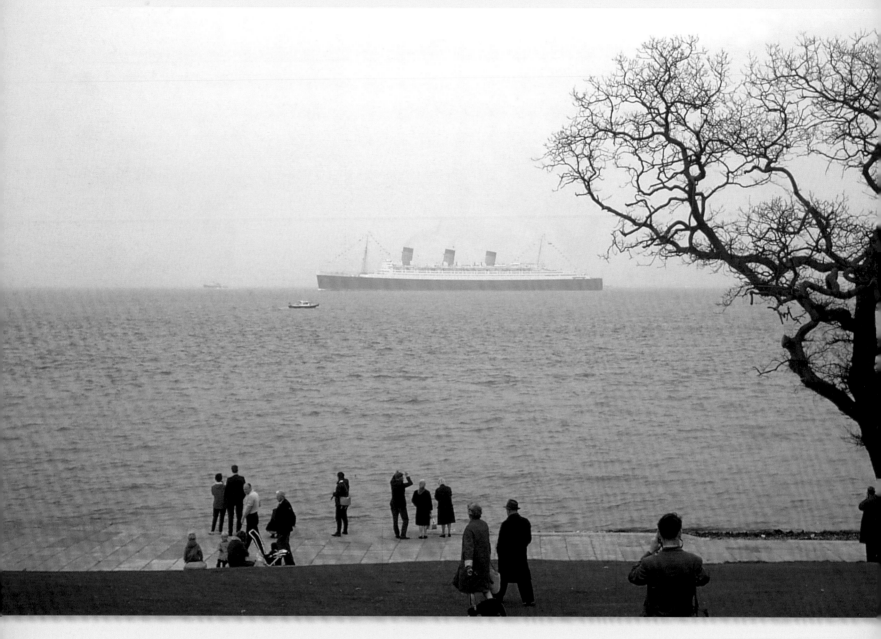

The *Queen Mary* was always popular with tourists and is seen here passing Egypt Point near Cowes on the Isle of Wight. (David Peters)

The *Queen Mary* passes Egypt Point at Cowes in 1964.
Top: (Ian Rolf/Britton Collection)
Bottom: (David Peters)

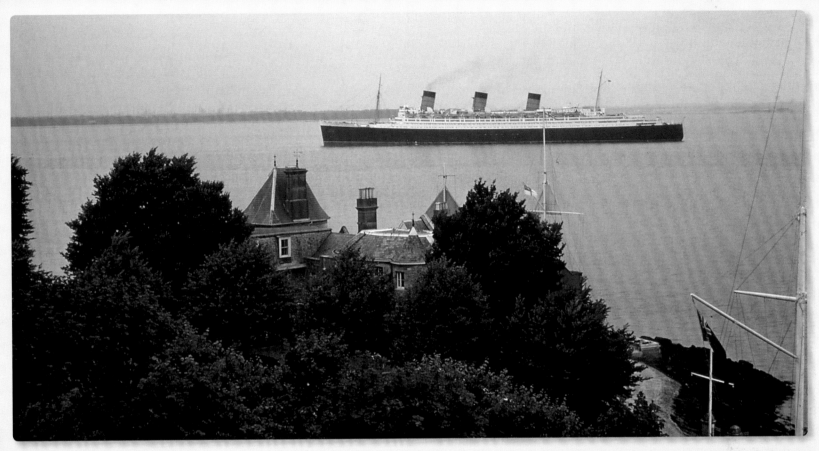

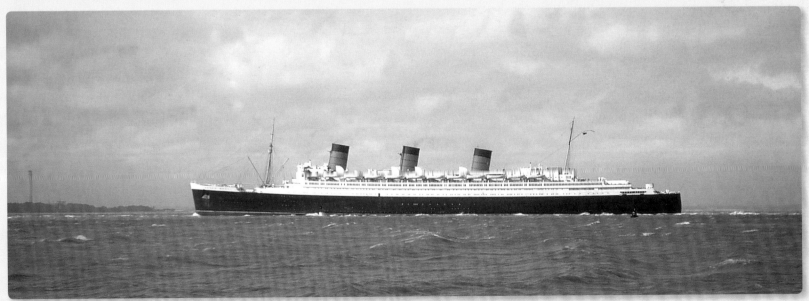

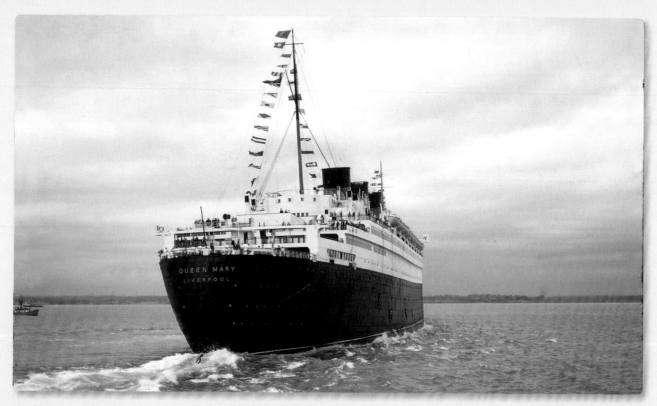

The *Queen Mary* passes the Calshot Spit Lightship on 27 September 1967. (A.E. Bennett)

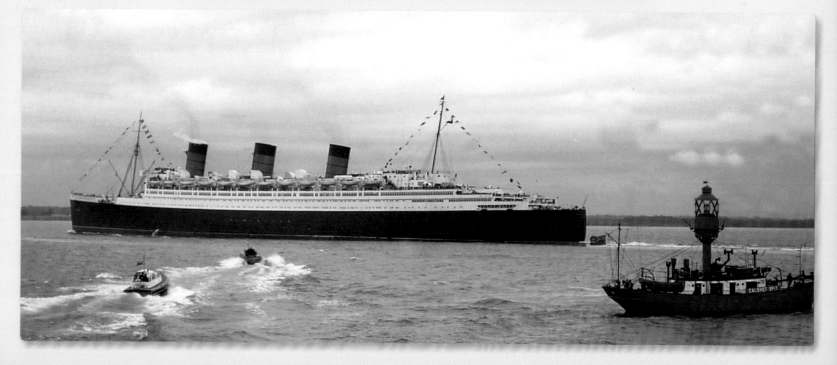

⬆ The Calshot Spit Lightship. (Norman Roberts/Britton Collection)

⬇ Pictured from the reed beds of the Hamble estuary, the *Queen Mary* slowly parades down Southampton Water against the backdrop of the New Forest. (Britton Collection)

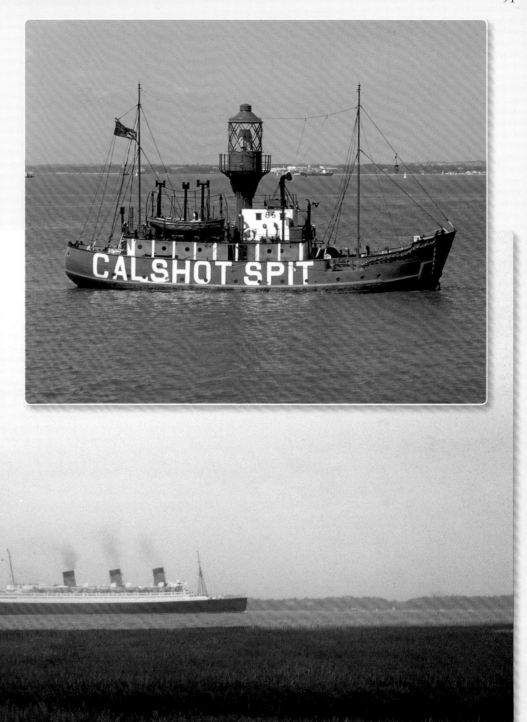

⇗ The *Queen Mary* beautifully decked out heads gingerly along Southampton Water past Calshot. (Britton Collection)

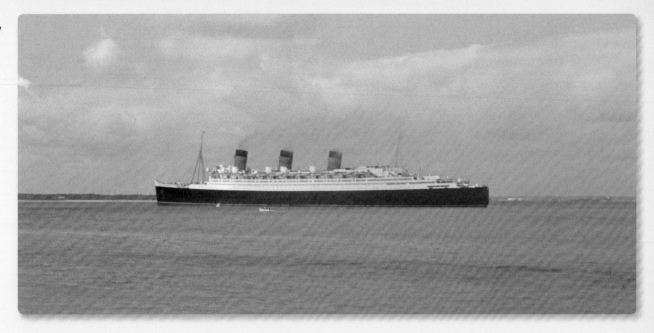

⇘ The *Queen Mary*, escorted by an Alexandra Towing Company tug, approaches Fawley on 27 September 1967. (A.E. Bennett)

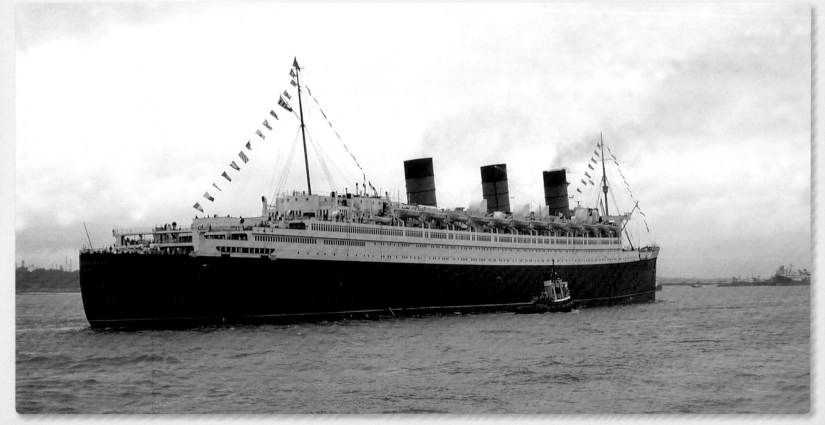

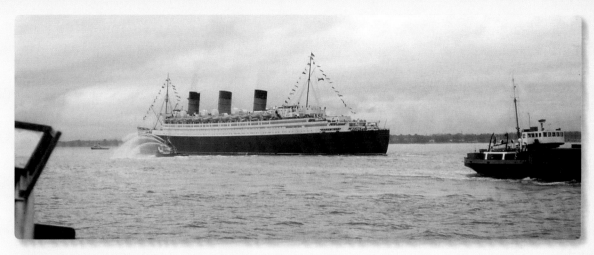

The *Queen Mary* sailing down Southampton Water. A Red Funnel fireboat sprays out a plume of water in tribute to the great liner. (A.E. Bennett)

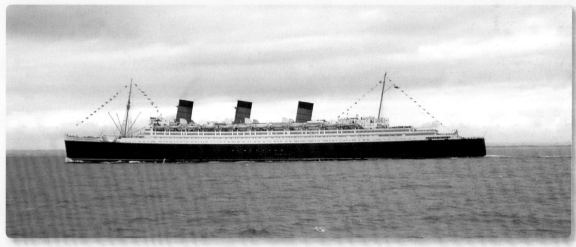

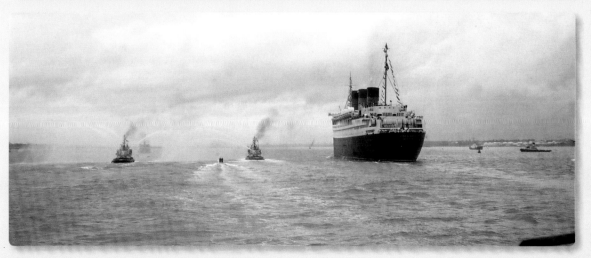

The whistle booms out to announce to all within a 30-mile radius that the grand old liner is returning home for the last time. (A.E. Bennett)

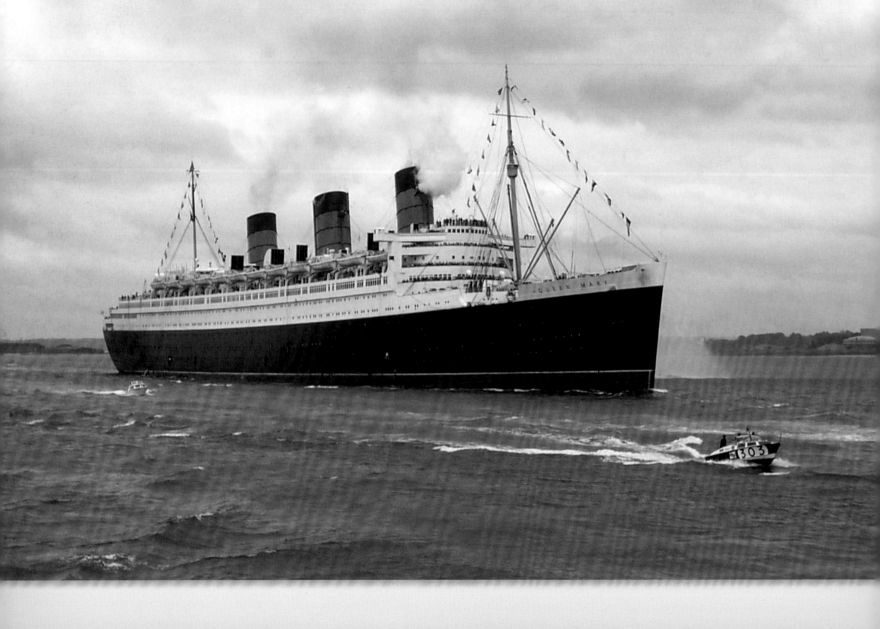

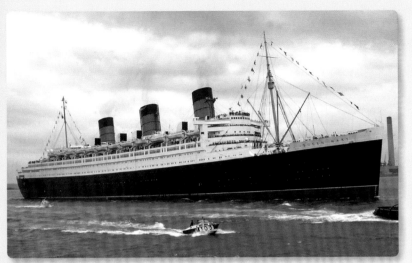
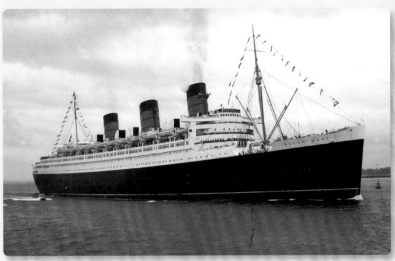

The *Queen Mary* heads down Southampton Water, admired by many on land and on board. There are doors open along the side of the ship from which the crew are peering out. (A.E. Bennett)

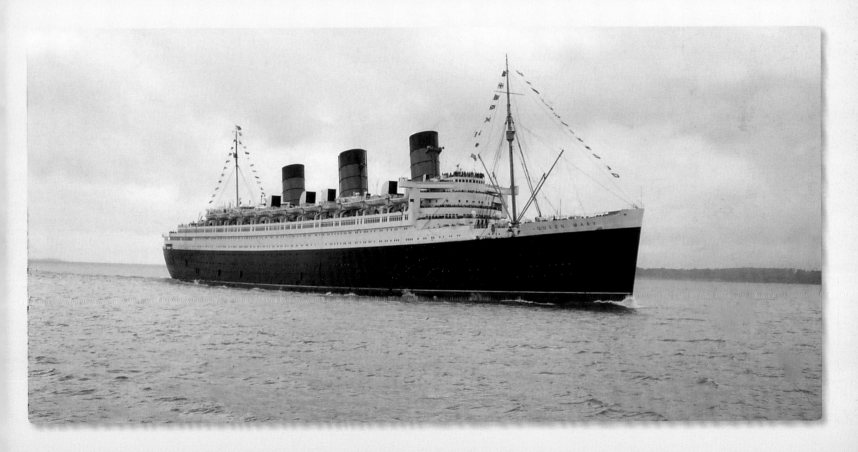

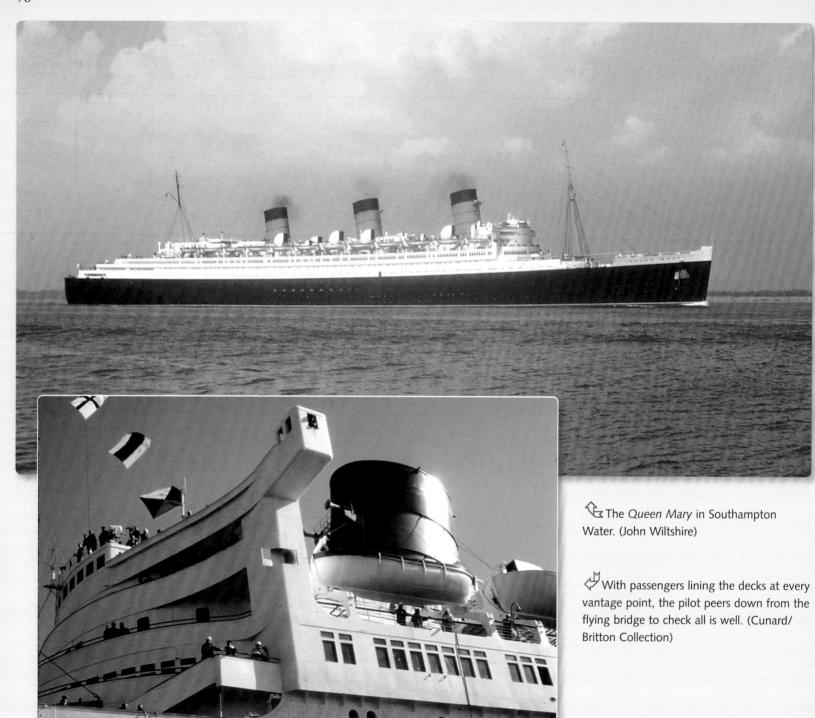

The *Queen Mary* in Southampton Water. (John Wiltshire)

With passengers lining the decks at every vantage point, the pilot peers down from the flying bridge to check all is well. (Cunard/ Britton Collection)

The *Queen Mary* sounds a salute from her whistles. The three steam whistles, two on the forward funnel and one on the middle funnel, were enormous in size. Each whistle weighed approximately a ton; the horn was over 6ft in length and 22in in diameter at the mouth. Designed to give a deep but not strident note, the whistles could be heard as far away as Winchester. (A.E. Bennett)

The end of a voyage is always a sad occasion, but this really was the final voyage into Southampton for the *Queen Mary* on 27 September 1967. (A.E. Bennett)

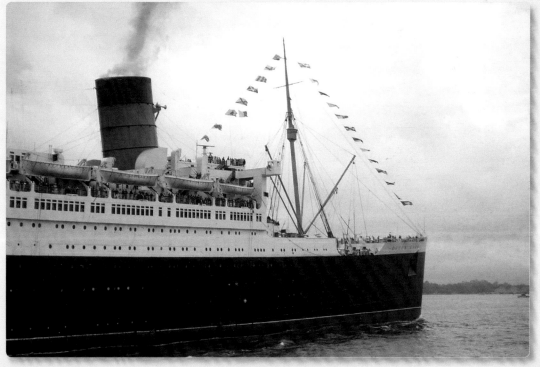

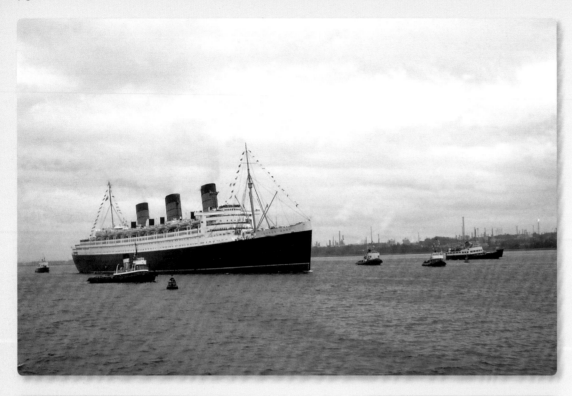

The *Queen Mary* is seen passing the Greenland Buoy near Fawley. She is assisted into port by the Alexandra tugs *Flying Kestrel* and *Brockenhurst,* and Red Funnel tugs *Sir Bevois, Hamtun, Dunose* and *Calshot.* (A.E. Bennett)

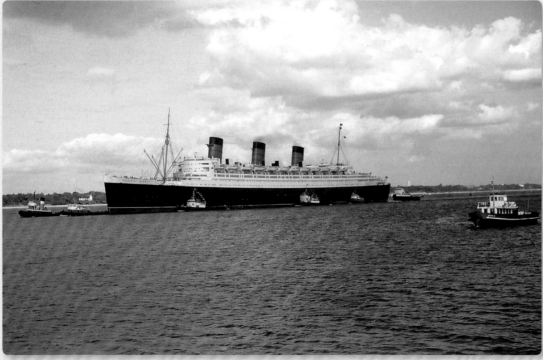

⇗ The sheer size of the *Queen Mary* close up was unbelievable. The docking pilot's launch is alongside with the pilot transferring via the shell door in the side of the ship. (Britton Collection)

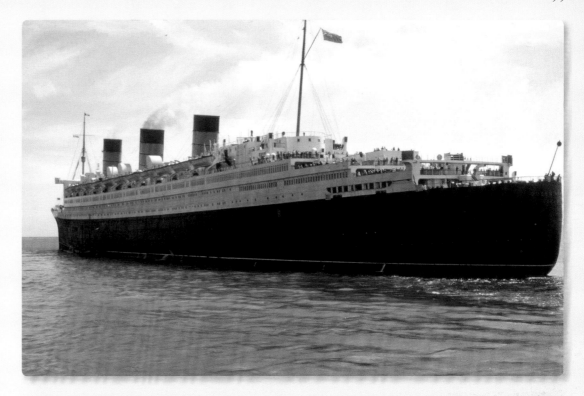

⇘ The tugs gently guide the *Queen Mary* into Ocean Dock for the last time on 27 September 1967. The reception for the *Mary* at Ocean Terminal was a very noisy celebration. Wives of the crew members aboard were heard to say, 'I can't believe this is the last time we will be here to meet her.' (A.E. Bennett)

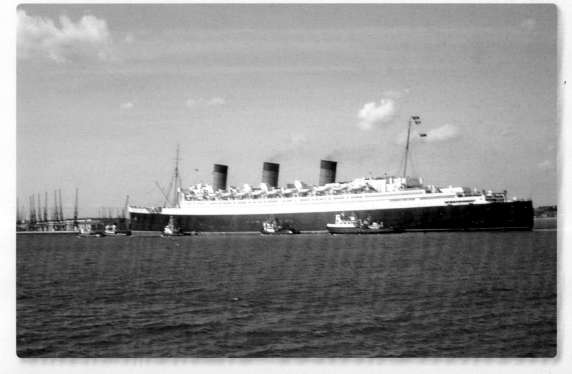

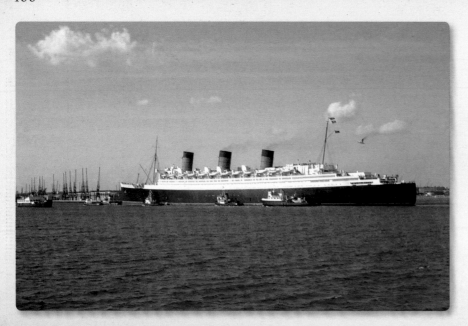

↖ The actual docking and undocking of the *Queen Mary* at Southampton was an operation requiring considerable expertise and no little finesse. The Ocean Dock was closed one way and when the *Mary* entered it displaced a vast amount of water which initially built up in front of the liner before flowing out around and past the ship. (A.E. Bennett)

↘ Red Funnel tug *Dunose* takes the strain to haul the *Queen Mary* out of Ocean Dock. She is to be moved to the New Dock in readiness for her final voyage to Long Beach. (A.E. Bennett)

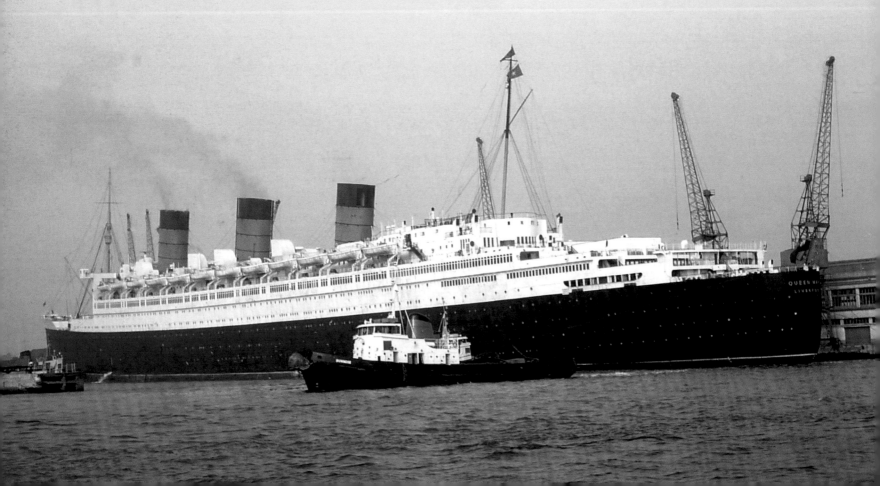

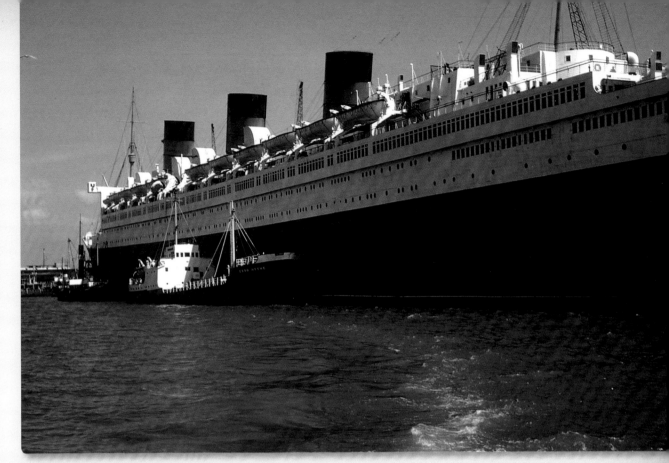

The Esso *Hythe* tanker moors alongside the *Queen Mary*, replenishing her thirsty fuel tanks at the rate of 400 tons an hour, while the *Inveritchen* barge removes waste materials from the sluice shoot. (John Cox)

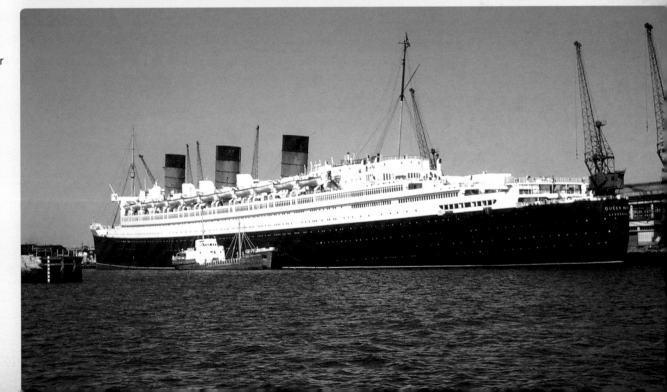

The *Queen Mary* is at rest in Ocean Dock being prepared for her next voyage, with a top-up of Bunker C fuel being loaded from the Esso *Lyndhurst*. (John Cox)

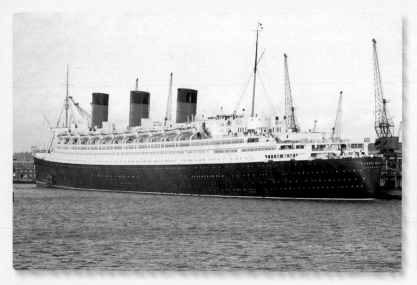

This was a scene that so many of us took for granted in the 1950s and '60s. The *Queen Mary* rests in Ocean Dock flanked by cranes, with painters touching up on a floating painting platform. We all thought it would go on forever. (Britton Collection)

Regal splendour as the three funnels of the *Queen Mary* dominate the skyline of Southampton. (A.E. Bennett)

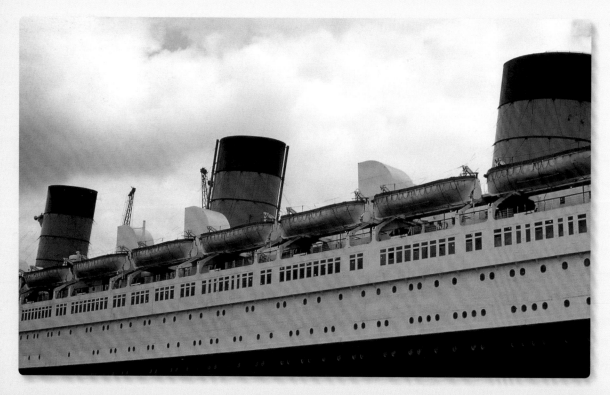

A close-up view of the *Queen Mary* in Ocean Dock showing some of the 2,000 portholes and windows, for which the area of glass was more than 2,500 square feet. (Britton Collection)

The *Queen Mary* in Ocean Dock next to the magnificent Ocean Terminal building. Also in Ocean Dock is the Cunard *Caronia* on the right and the Alexandra Towing Co. tug *Ventnor* in the foreground, June 1966. Unlike mooring ropes, those used for towing were made of steel cable except for a short length of fibre rope on the tug's hook to provide some stretch. (Norman Roberts/ Britton Collection)

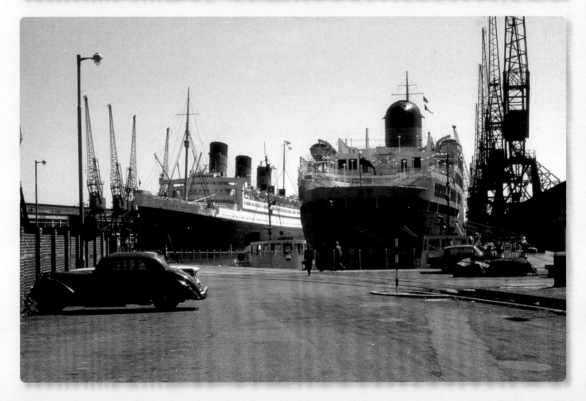

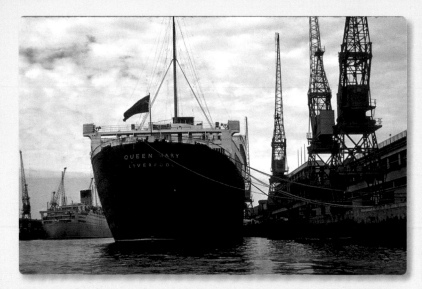

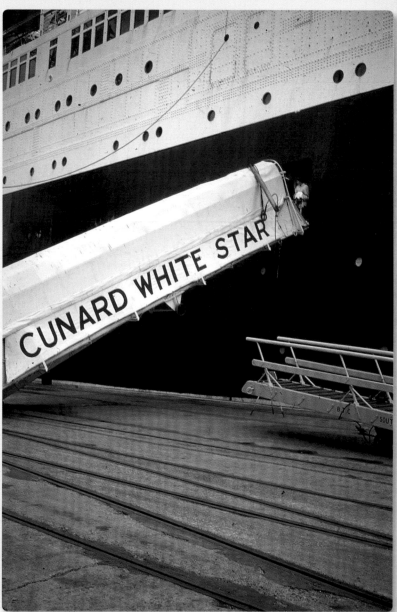

A view from sea level in Ocean Dock with the Cunard *Caronia* on the left and the stern of the *Queen Mary*. Note the Blue Ensign flag proudly flying. (Britton Collection)

The portable gangway in Ocean Dock leading on to the *Queen Mary* with the legend, Cunard White Star, proudly spelt out along the canvass covering in 1953. (Britton Collection)

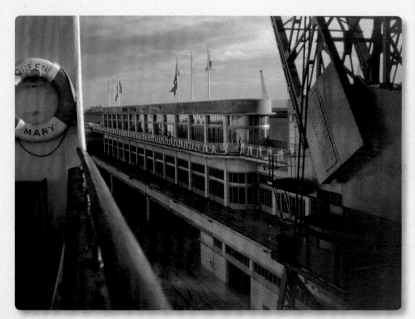

The Union Jack, Stars and Stripes and Cunard flags flutter in the breeze above Ocean Terminal as viewed from the starboard side of the *Queen Mary*'s decks. (Britton Collection)

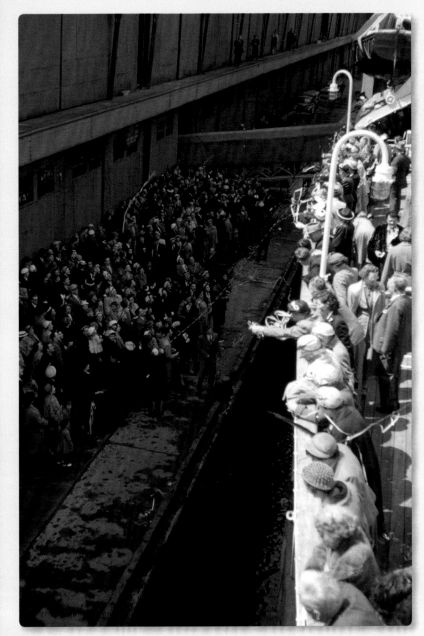

🖎 This was the daily view that greeted passengers at the end of Hythe Pier waiting to board the Hythe ferry when the *Queen Mary* was in port in Ocean Dock. (Britton Collection)

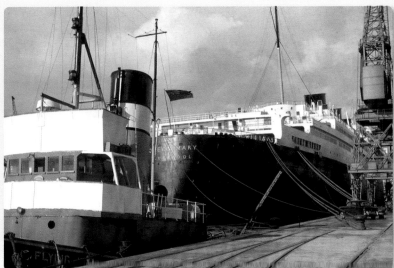

🖎 Dockside farewells in 1953 as passengers aboard the *Queen Mary* throw streamers down to friends and family below on the quayside at Ocean Dock. (Britton Collection)

🖎 The Alexandra Towing Co. tug *Flying Kestrel* is tied up at the rear of the *Queen Mary* in Ocean Dock in March 1963. The mooring ropes on the *Queen Mary* were very traditional; the new synthetic ropes were not for her. To the end the *Queen Mary* used a 9in-circumference manila fibre rope. Each rope was about 120 fathoms in length, weighed about 18cwt and had a breaking strain of 31½ tons. (John Cox)

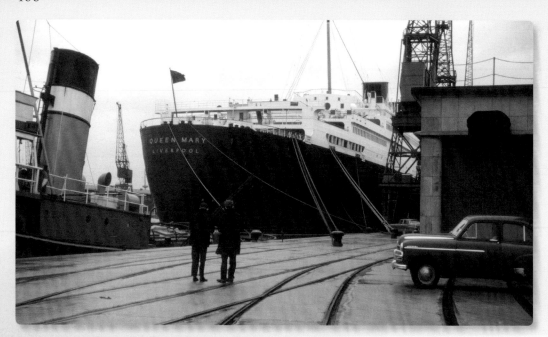

The Alexandra Towing Co. tug *Flying Kestrel* is tied up at the rear of the *Queen Mary* in Ocean Dock. Two shipping enthusiasts stand and watch. (Ian Rolf/Britton Collection)

A sad occasion was the British Seaman's Strike of June 1966. Photographer David Peters, however, was able to explore the abundance of shipping laid up in the port. Here we see the RMS *Queen Mary* with the Union Castle Line's *Roxburgh Castle* and *Rowallan Castle* astern of her. On the opposite side of Ocean Dock are Cunard's *Carmania* and two larger Union Castle Line ships. (David Peters)

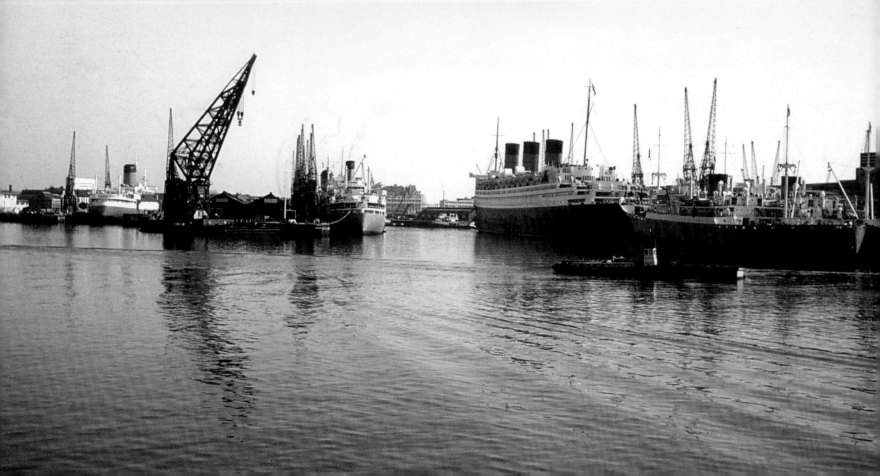

⇗ First light at the King George V Graving Dock on 16 November 1952 with the *Queen Mary* undergoing her annual refit. Situated at the extreme west end of the New Docks, the dry dock was officially opened and named by King George V on 26 July 1933. The dry dock had an overall length of 1,200ft and a width at the entrance of 135ft. (Pursey Short/Britton Collection)

⇙ An aerial view of the *Queen Mary* in the King George V Graving Dock, believed to have been taken in November 1952. Note the repainting in red oxide of the starboard upper decks. (Britton Collection)

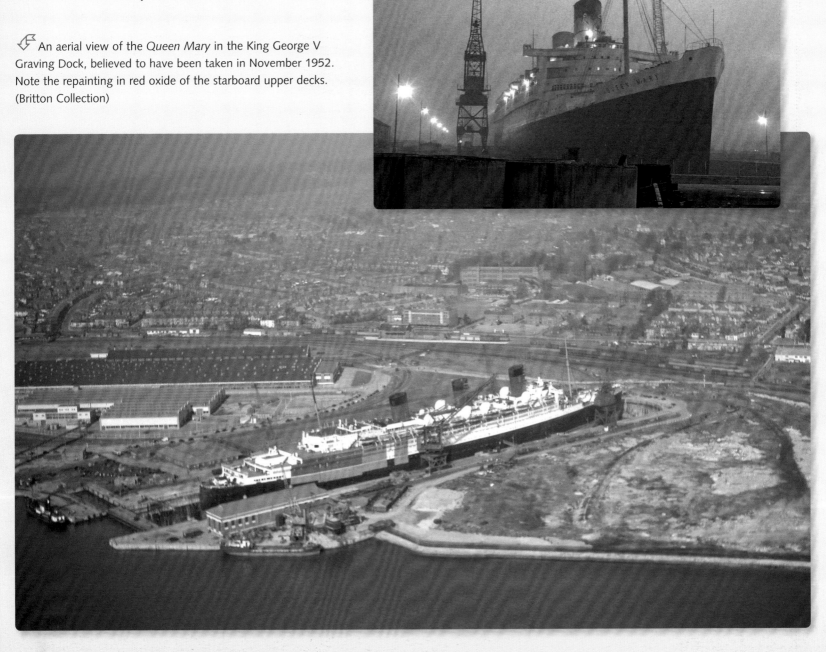

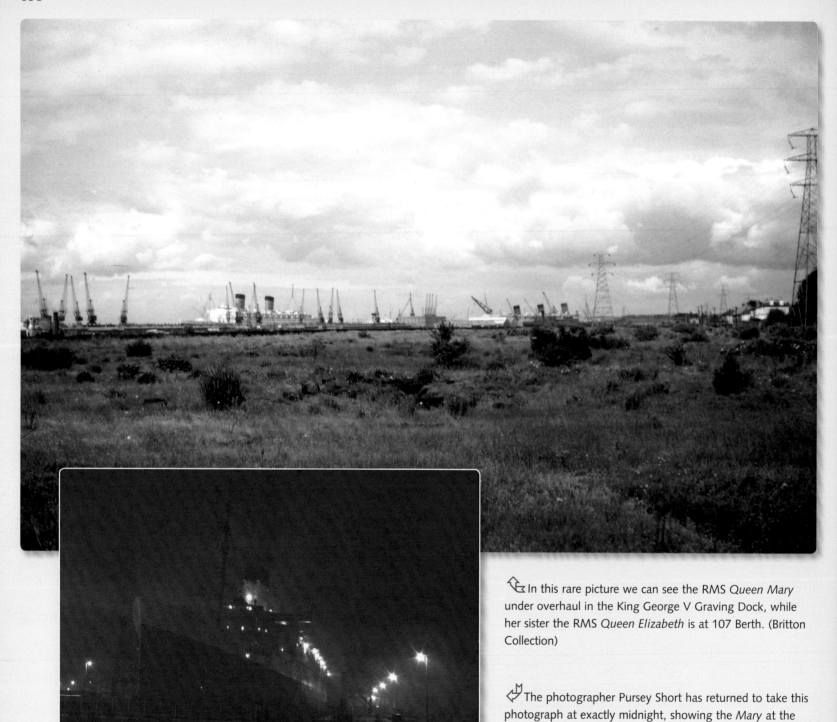

In this rare picture we can see the RMS *Queen Mary* under overhaul in the King George V Graving Dock, while her sister the RMS *Queen Elizabeth* is at 107 Berth. (Britton Collection)

The photographer Pursey Short has returned to take this photograph at exactly midnight, showing the *Mary* at the King George V Graving Dock on 16 November 1952. (Pursey Short/Britton Collection)

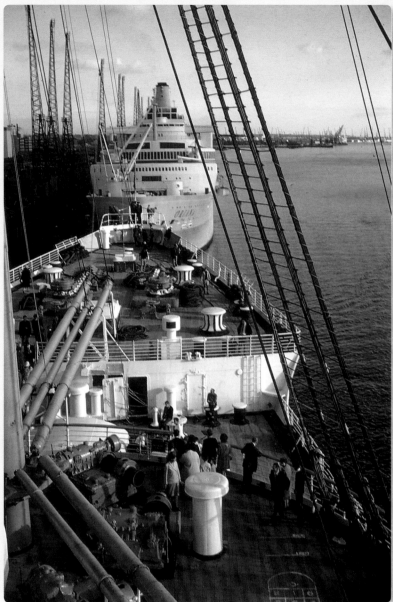

☜ Looking down into the depths of the King George V Graving Dock at the aft end of the *Queen Mary* at 8.30 a.m. on 16 November 1952. Scaffolding surrounds the streamlined 140-ton rudder. Doors in the side of the rudder allow it to be inspected internally. One of the 35-ton bronze propellers lies flat on the floor, removed ready for inspection. (Pursey Short/Britton Collection)

☟ The P&O ship *Oriana* and the *Queen Mary*. The *Mary* was being prepared for her final voyage to Long Beach and many surplus items were taken ashore on 30 October 1967. Sid Deeming on the *Oriana* flew the signal, 'Adieu, great Queen.' (John Goss)

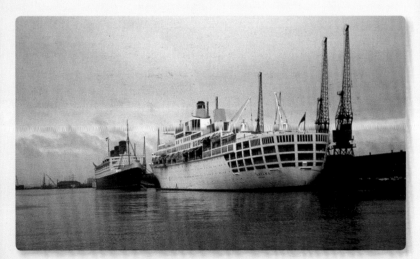

☞ On board the *Queen Mary* on 30 October 1967, visitors pay their final respects to the ship. Ahead of the forecastle is P&O's *Oriana*. (Cyril S. Perrier/Britton Collection)

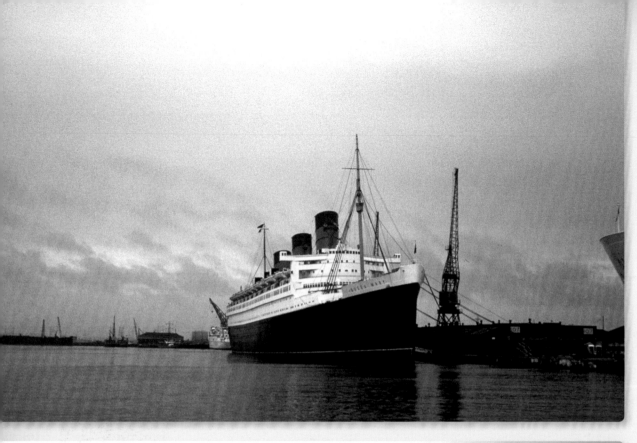

Standing alone at 107 Berth on 30 October 1967, the *Queen Mary* looks forlorn. The preparation and clearing of the *Mary* before her last voyage was undertaken in Southampton's New Docks. Many thousands of surplus items found their way ashore into the homes of the crew and dock workers. To this day they are treasured as family heirlooms. (John Goss)

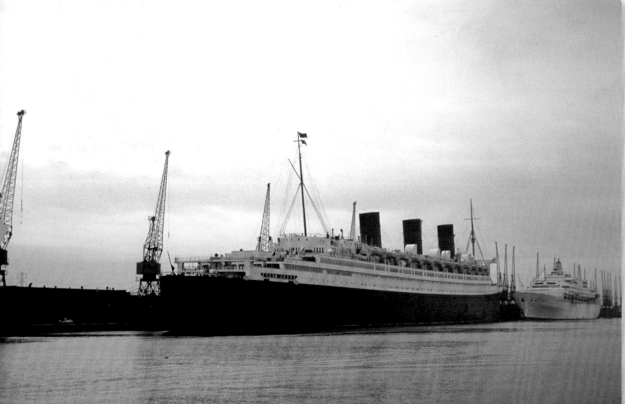

Throughout 30 October 1967 many former crew members visited the *Queen Mary* to pay their last respects. (John Goss)

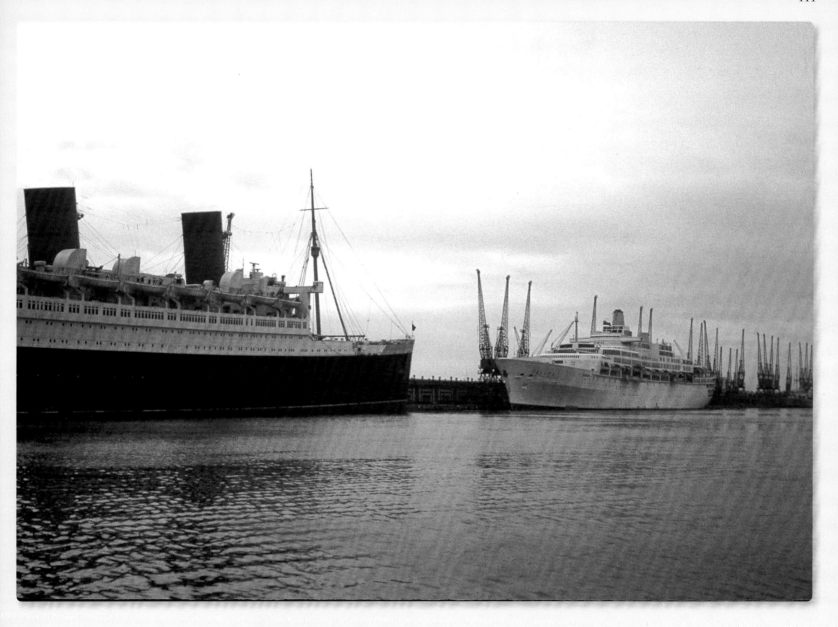

The *Queen Mary* and the P&O *Oriana*. (John Goss)

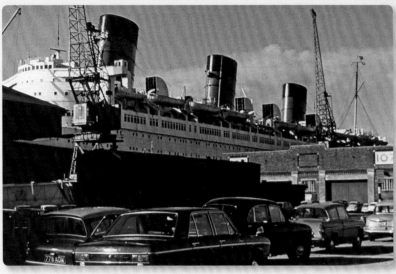

Looking towards Ocean Dock from Mayflower Park, the three distinctive funnels of the *Queen Mary* dominate the skyline. To the right of the picture is the Royal Pier. Of interest to transport enthusiasts are two Southampton Corporation Guy double-decker buses. (G.R. Keat/Britton Collection)

The *Queen Mary* is prepared for her final voyage and is seen resting at 107 Berth in the New Docks in October 1967. (Commodore G.T. Marr)

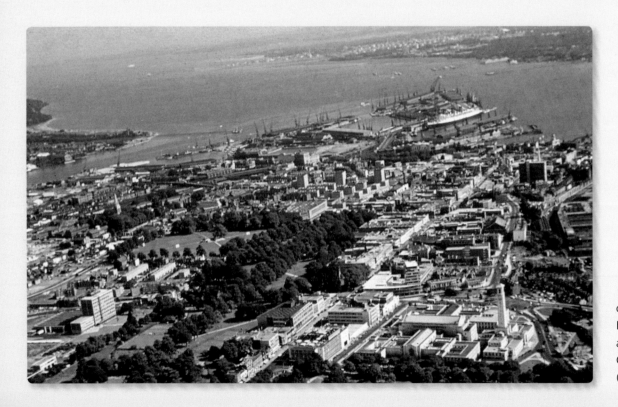

This remarkable aerial view looks out towards the Isle of Wight over the Itchen estuary. The *Queen Mary* is seen at rest in Ocean Dock with Southampton Civic Centre visible in the foreground. (Esso/Britton Collection)

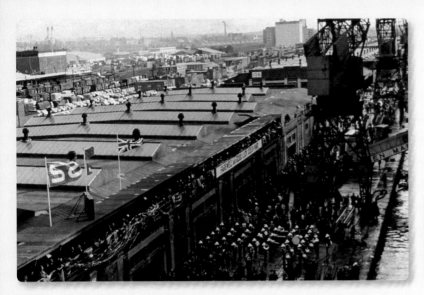

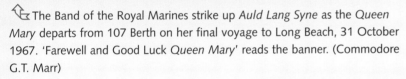

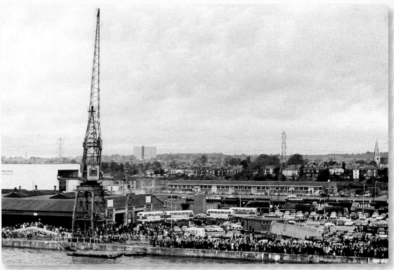

The Band of the Royal Marines strike up *Auld Lang Syne* as the *Queen Mary* departs from 107 Berth on her final voyage to Long Beach, 31 October 1967. 'Farewell and Good Luck *Queen Mary*' reads the banner. (Commodore G.T. Marr)

The dock cranes bow their jibs in salute as the *Queen Mary* sails slowly down Southampton Water. Crowds of well-wishers cheer and wave. Note the City of Southampton Guy and AEC buses and the pink and white livery Mr Whippy ice-cream van. (Commodore G.T. Marr)

The air was full of coloured streamers and the quayside at 107 Berth was overflowing with waving former crew members, friends and relations of the passengers and the families of the crew as the *Queen Mary* sailed away down Southampton Water for the last time. Music from the Band of the Royal Marines filled the air and at this exact point, as heard on the soundtrack of a colour film, they were playing *Rule Britannia*. (Commodore G.T. Marr)

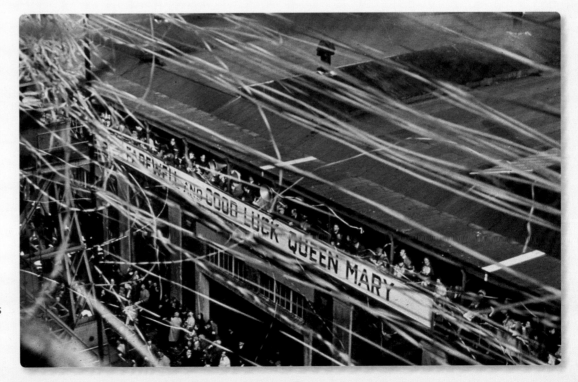

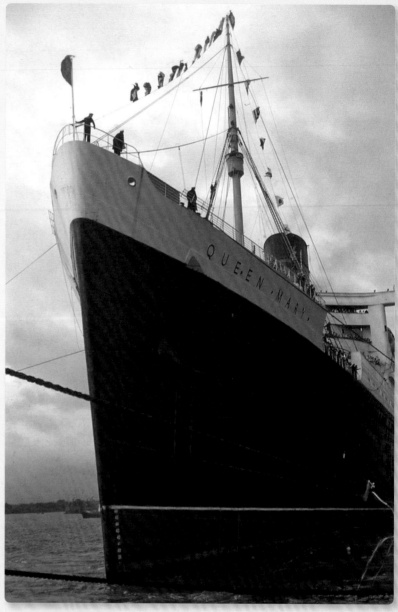

Captain Treasure Jones blows a final traditional triple whistle salute to the city of Southampton from the gigantic steam whistles of the *Queen Mary*. (Commodore G.T. Marr)

The crew looks out in disbelief from the decks of the *Queen Mary*. They thought this day would never come. At the end of this final voyage to Long Beach many of them would face an uncertain future and redundancy. (Commodore G.T. Marr)

A sad moment for the crew of the RMS *Queen Mary* and the people of Southampton, as the grand old lady casts off from 107 Berth on 31 October 1967. She was dressed overall and flew a paying-off pennant. Ahead lay a thirty-nine-day voyage to Long Beach of 14,559 miles. (Britton Collection)

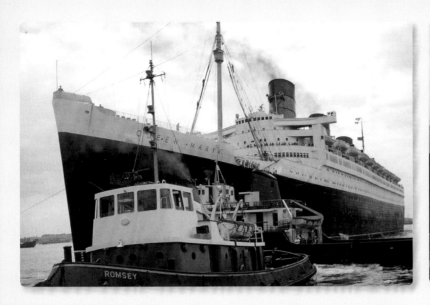

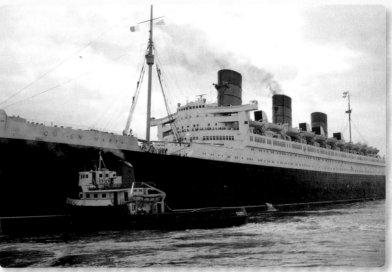

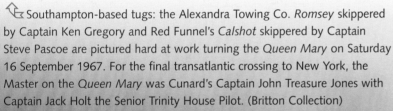

Southampton-based tugs: the Alexandra Towing Co. *Romsey* skippered by Captain Ken Gregory and Red Funnel's *Calshot* skippered by Captain Steve Pascoe are pictured hard at work turning the *Queen Mary* on Saturday 16 September 1967. For the final transatlantic crossing to New York, the Master on the *Queen Mary* was Cunard's Captain John Treasure Jones with Captain Jack Holt the Senior Trinity House Pilot. (Britton Collection)

Captain Steve Pascoe gently applies full power on the tug *Calshot* as she pushes *Queen Mary* with all her might. (Britton Collection)

A magnificent head-on view of the industrious tugs at work gently swinging the *Queen Mary* around ready for her final transatlantic voyage, Saturday 16 September 1967. (Britton Collection)

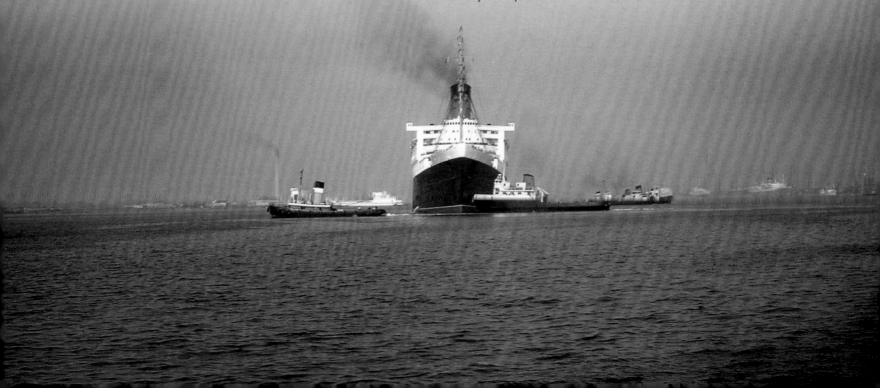

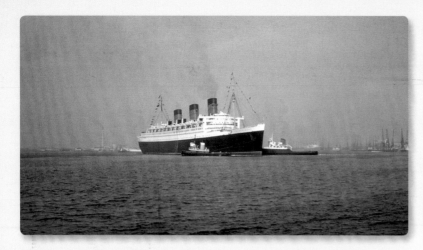

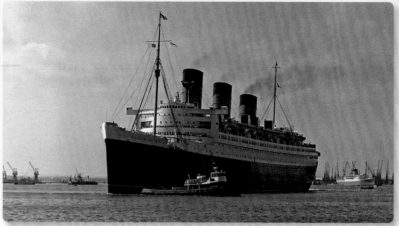

The swinging procedure is almost complete, Saturday 16 September 1967. She will soon be heading down Southampton Water to Cherbourg and then to New York. (Britton Collection)

Misty eyes at Western Shore as the *Queen Mary* sails down Southampton Water for the last time on Tuesday 31 October 1967. She had sailed 3,795,000 miles, carrying 2,115,000 passengers, earning Cunard £132 million in her thirty-one-year reign. She sailed from 107 Berth at 9.30 a.m. with 1,093 passengers and 806 crew. As the *Mary* passed the row of dock cranes, each one nodded their jibs in salute. (Marc Piche)

The sunlight shines on the majestic three funnels of the RMS *Queen Mary* as she is manoeuvred by a diminutive Alexandra Towing Co. tug. Crowds of passengers and crew line the rails to watch the action. Immediately behind her is an escort of sightseers in a harbour pleasure boat, while in the New Docks a Union Castle ship is being prepared for the voyage to South Africa. (Britton Collection)

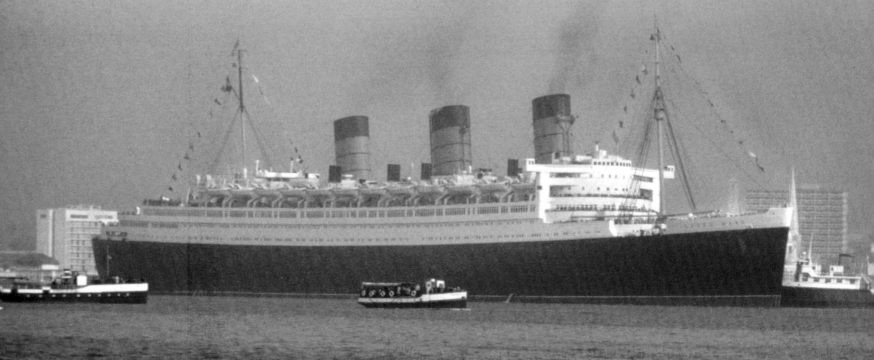

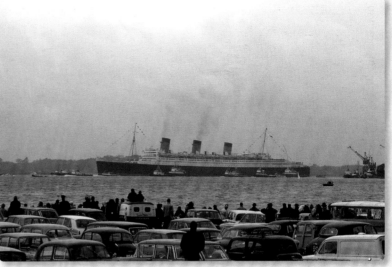

The Esso tanker *Hythe* is uniquely dressed for the occasion as a tribute to the *Queen Mary*. Watched by thousands of onlookers, the *Queen Mary* slowly heads away down Southampton Water for the final time, with her 310ft paying-off pennant fluttering in the wind behind her, 10ft for each of her years in service. (Britton Collection)

The car park is full to overflowing with vintage cars as their drivers and passengers take a last look at the *Queen Mary* flying her paying-off pennant and escorted by a flotilla of Red Funnel and Alexandra Towing Co. tugs. (Britton Collection)

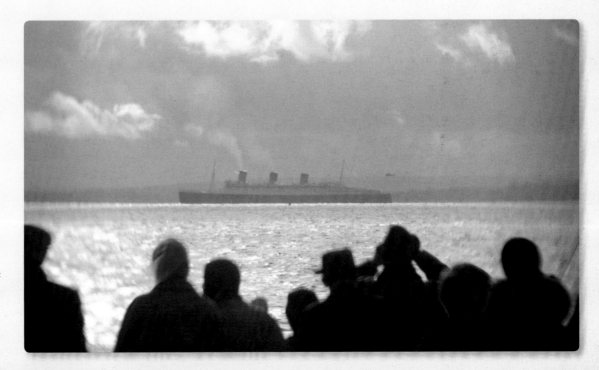

Thousands watch the final departure of the *Queen Mary* from every vantage point possible; author Andrew Britton watches from Western Shore, Netley. (Britton Collection)

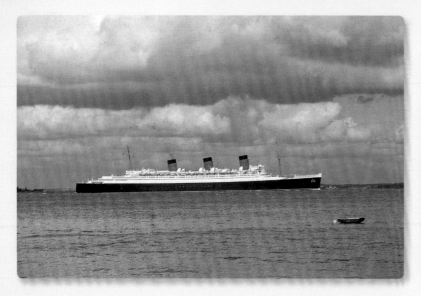

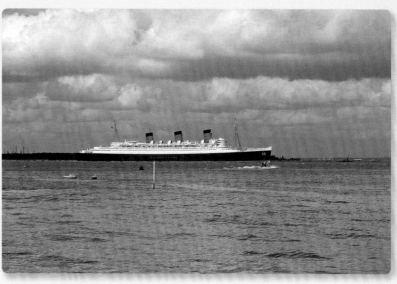

The *Queen Mary* off Cowes on the Isle of Wight heading for Cherbourg. Just behind the liner it is possible to make out the Royal Victoria Military Hospital at Netley which was built in 1855. (R.J. Blenkinsop)

The *Queen Mary* off Cowes. Behind her is the backdrop of Fawley Oil Refinery and Calshot. (R.J. Blenkinsop)

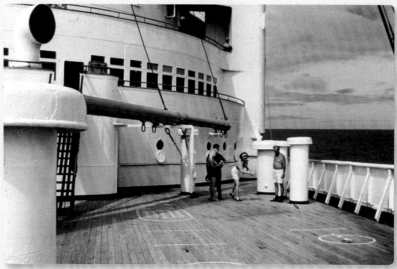

The view ahead from the bridge of the *Queen Mary* on the final voyage to Long Beach in October 1967. (Commodore G.T. Marr)

The weather was very hot when this picture was taken as evidenced by the passengers in summer attire playing deck quoits on the final voyage of the *Queen Mary*, November 1967. (Commodore G.T. Marr)

119

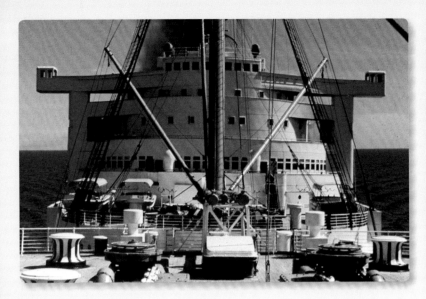

A view taken from the forecastle of the *Queen Mary* when heading south on her final voyage into retirement. (Commodore G.T. Marr)

Sea ball, the last night on the *Queen Mary*, December 1967. (Commodore G.T. Marr)

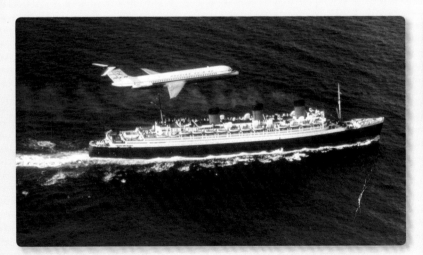

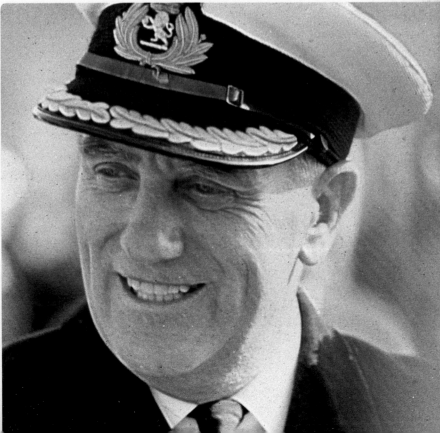

Carnations are dropped on the *Queen Mary* by a DC-9 jet as a welcome to Long Beach. (Cunard)

Portrait of Captain John Treasure Jones, the last Master of the RMS *Queen Mary* in October 1967, taken by his dear friend and colleague Commodore Geoffrey Trimpleton Marr. (Commodore G.T. Marr)

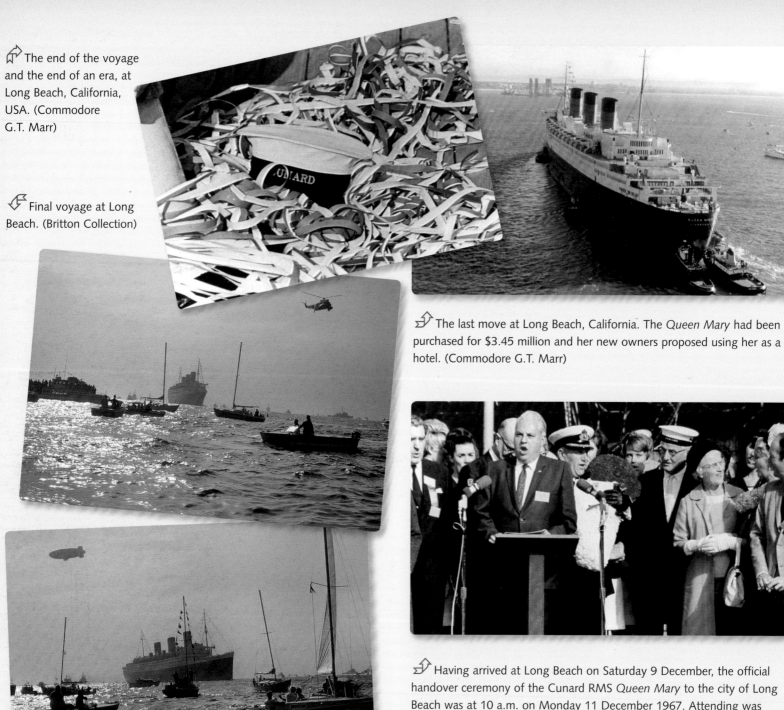

⇗ The end of the voyage and the end of an era, at Long Beach, California, USA. (Commodore G.T. Marr)

⇙ Final voyage at Long Beach. (Britton Collection)

⇗ The last move at Long Beach, California. The *Queen Mary* had been purchased for $3.45 million and her new owners proposed using her as a hotel. (Commodore G.T. Marr)

⇗ Having arrived at Long Beach on Saturday 9 December, the official handover ceremony of the Cunard RMS *Queen Mary* to the city of Long Beach was at 10 a.m. on Monday 11 December 1967. Attending was Mayor Wade and Captain John Treasure Jones. Captain Jones said, 'I was the Captain of the *Mauretania*. I took her to the breakers at Inverkeithing in Scotland. Bringing this ship here, at least means she will live.' (Commodore G.T. Marr)